Rosemary,
Happy Painting!
Susan Vitali
11-12-94

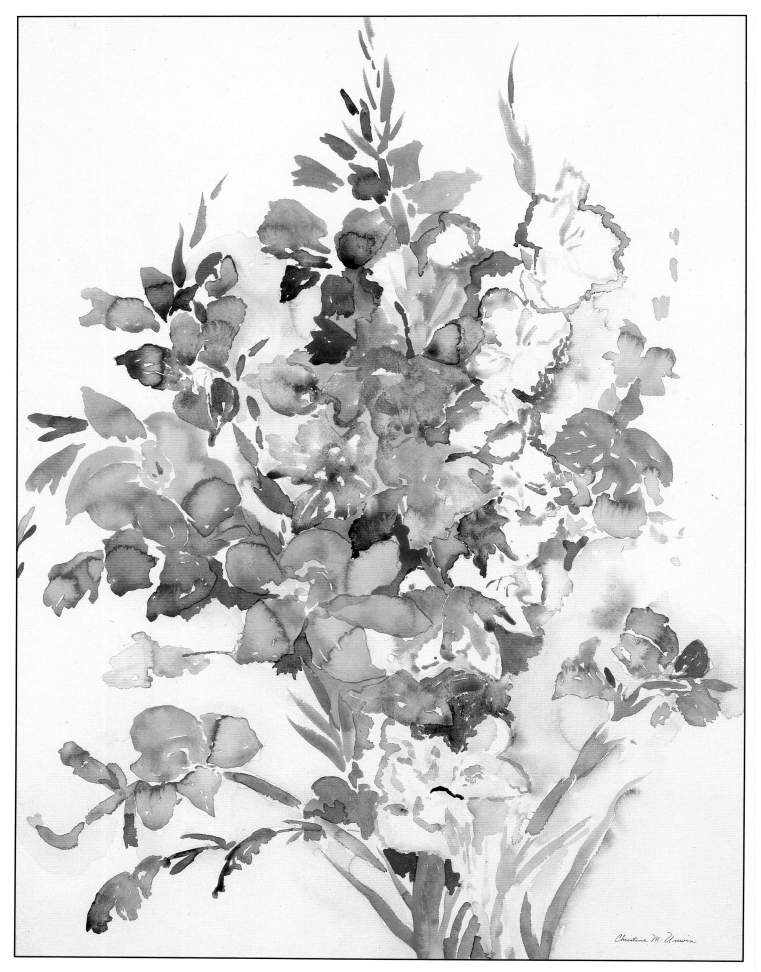

Christine M. Unwin *Gladiolus* 22'' x 30'' Watercolor

The Artistic Touch

Acknowledgments

This book is dedicated to my husband, Don. Without his organizational skills, determined spirit and business experience, this book would not have been possible. He did all of the hard work, while I did the easy part.

To: Mitzi Hale, my first inspiration — as a woman and as an artist.

To: Diane Reiman, who first introduced me to watercolor — the medium that became the love of my life.

To: All of the teachers I have studied with. Each has influenced me in a different way, especially Nita Engle, the best teacher of all.

To: Jack and Christel Sanecki, who proof read the text and gave us valuable insights.

To: Every artist whose work appears in my book. Thank you, thank you, thank you. You're great!

To: Susan, Angelo, Olivia, Laura, Greg, David, Carol and Diana

By Christine M. Unwin

Creative Art Press
West Bloomfield, Michigan

The Artistic Touch — Ideas & Techniques

Copyright © 1995 by Creative Art Press

ISBN 0-9642712-0-6
98 97 96 95 94 / 1 2 3 4 5

Library of Congress Cataloging-in-Publication Data

Cataloging data for this book is available from the Library of Congress

Manufactured in Hong Kong

First Edition, 1995

Table Of Contents

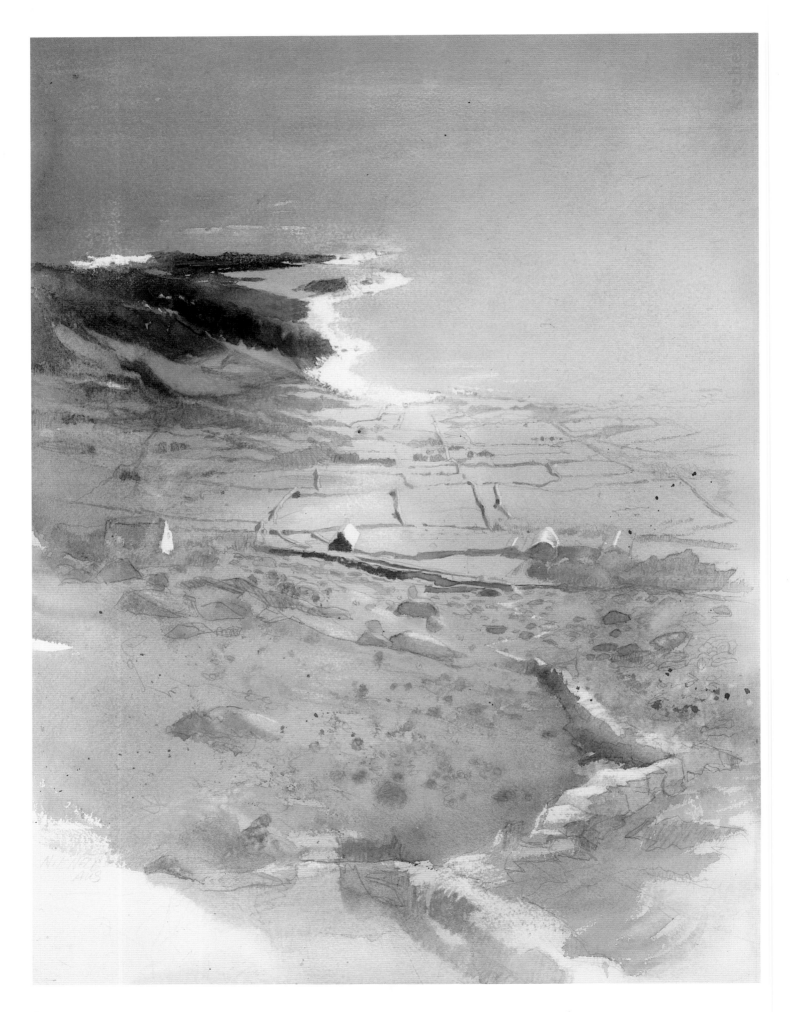

6

***Paintings that are felt, experienced
or lived through before they are
painted are the ones that live on . . .***
Nita Engle

Nita Engle *Ireland and the Sea* **22" x 30" Watercolor**

Paintings that are felt, experienced or lived through before they are painted are the ones that live on after they are painted. If you are a landscape painter, it is important to gather material directly from reality even if you depart from it later. This is what can give life to your painting.

All of my work is a response to something I've seen or experienced; all of my landscapes are real places you can find on a map, whether painted from memory or painted on the scene.

Because I've been able to travel extensively, I have had the opportunity to see wonderful potential landscape paintings all over the world. My explorations have been a great benefit, because I now travel with a sharper, more observant eye, looking for new experiences and material to paint.

Quite another kind of adventure was driving on the west coast of Ireland, around the Ring of Cary. I gradually became aware that we had been climbing and climbing for miles with no view but up. Then one more turn of the road, and we came out on top — high above the sea with a breathtaking view of the whole countryside stretched out below. If I had not been there in person, I would not have been able to imagine the scope of what I saw or the emotions I felt. It was here that I painted Ireland and the Sea.

Gwen Tomkow *Traverse Sunset* 22" x 30" Watercolor

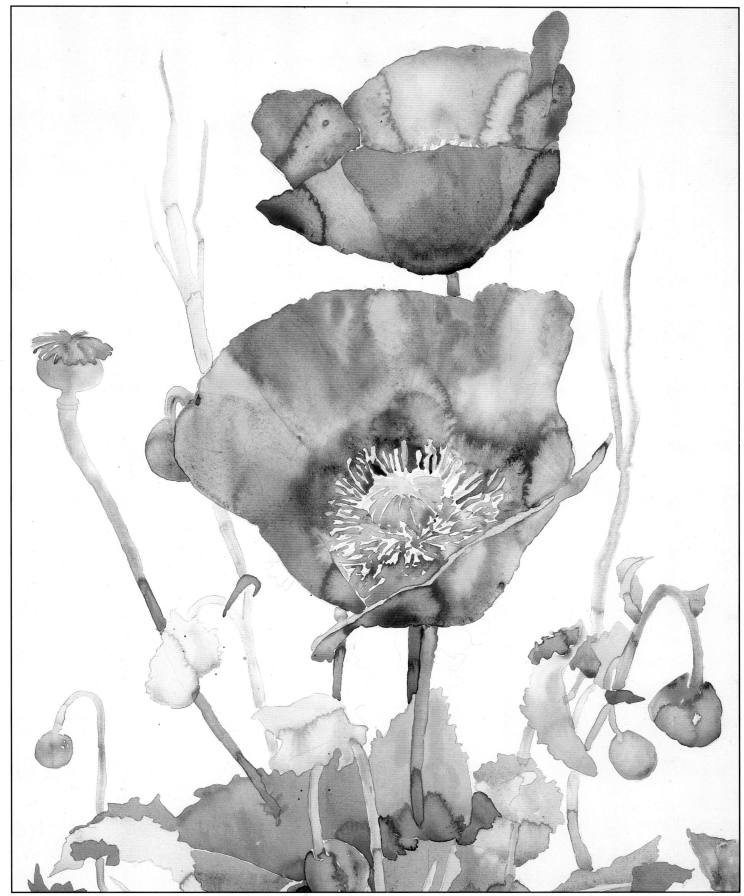

Christine M. Unwin *Poppies* 22" x 30" Watercolor

I saw these Poppies in Tangier while on an art workshop cruise. They were blooming in the garden of Malcolm Forbes' former Tangier home which now is a museum. I felt compelled to paint them. I knew immediately how the painting would look when finished. That's unusual for me. I completed six paintings of this subject before I was finally satisfied with this version, which was juried into the 1993 Art & Flowers Show at the Detroit Institute of Arts.

Landscape

The autumn sun slowly dipped behind the trees and hills. . .

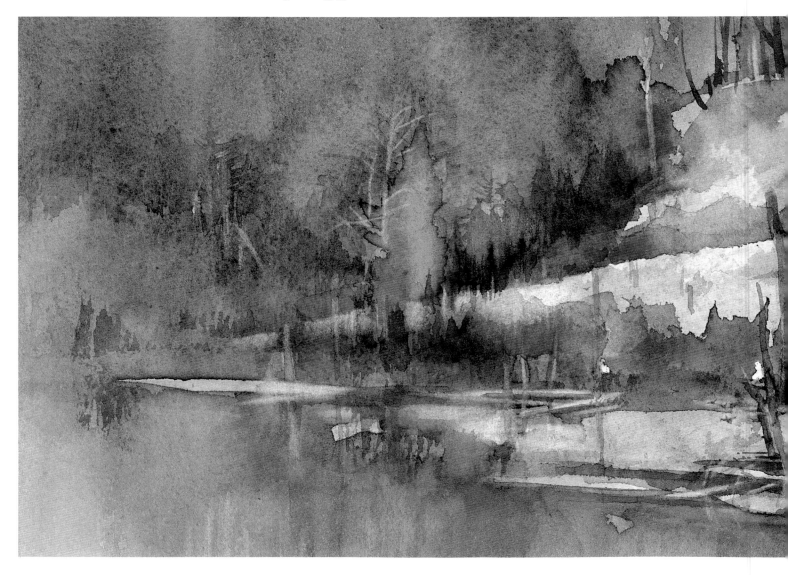

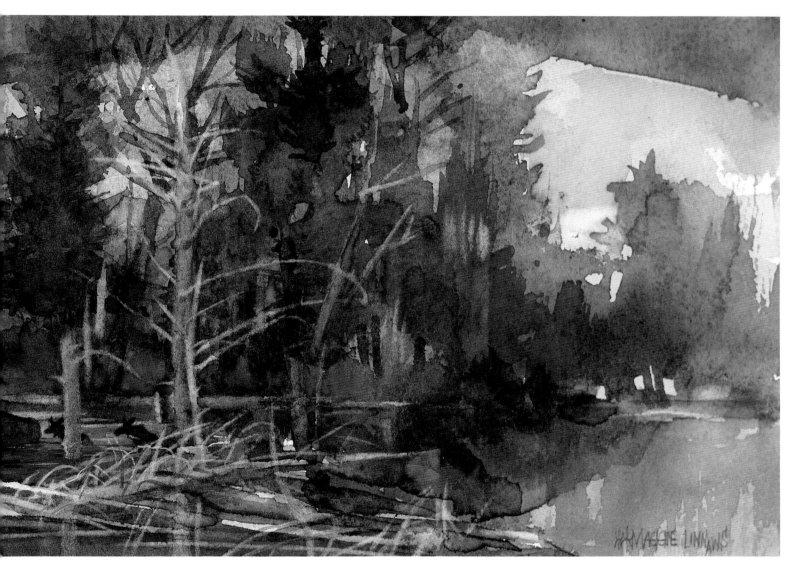

Maggie Lynn
Hazy Afternoon 7" x 18" Watercolor

A beautiful ending occurred, after fishing on Tamarack Lake, when my husband and I came upon a cow moose and her two calves nibbling on water plants. The autumn sun slowly dipped behind the trees and hills when the moose finally disappeared into the woods.

Hazy Afternoon was originally painted as a watercolor demonstration to show how not to pull a painting off in opposite directions as well as to show how not to divide a painting into equal proportions. After the instructional splashes of the paint were done to get the ideas across to the students, those particular splashes and strokes were hosed off with water. Yes! Hosed off. The moose were added to make the final point.

. . . there are lots of potential painting scenes, fields full of wild flowers, ravines and banks edged with cedar, birch and poplar trees, and the lake side beach itself is littered with driftwood.

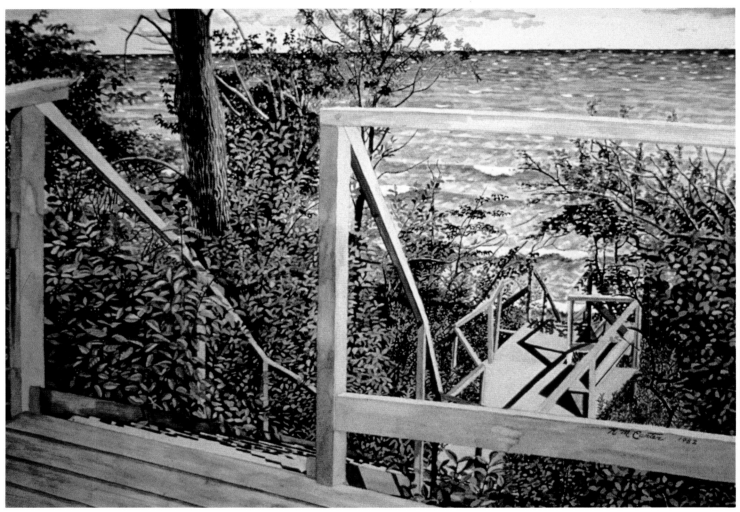

Karen Carter Van Gamper *Stairways* 22" x 30" Watercolor

 I develop watercolor landscapes on location. In the summer, I paint at the family cottage near Forest, Ontario on the Canadian side of Lake Huron. The cottage is not far from my home in Michigan, just north of the Blue Water Bridge, and has been in our family for over 60 years. In style, it's a farmhouse with porches on three sides and a wood burning stove in the kitchen. It is situated on a bluff, 100 feet above the water. From this vantage point, there are lots of potential painting scenes, fields full of wild flowers, ravines and banks edged with cedar, birch and poplar trees, and the lake side beach itself is littered with driftwood. I usually split the day in half. I begin with a "morning" subject followed by an "afternoon" subject. In this way, the light source remains constant: I spend very little time away from the subject, returning to the location each day. I can spend about 30 to 60 hours painting a 22" x 31" sheet of d'Arches and as long as two months for a 37" x 45" painting.

 My favorite morning subject is day lilies and sweet peas growing out in the fields. These flowers bloom in profusion from mid-June to mid-July. Another favorite subject is the stairway that goes down to the beach from the bluff. The stairs are constructed in a variety of styles, and descend and ascend beautifully through the trees on the bank looking out over vistas of water and sky. I especially enjoy the way in which the stairways lead the eye into the composition, creating a greater depth of perspective.

I watched the mist burn off and smelled the forest.

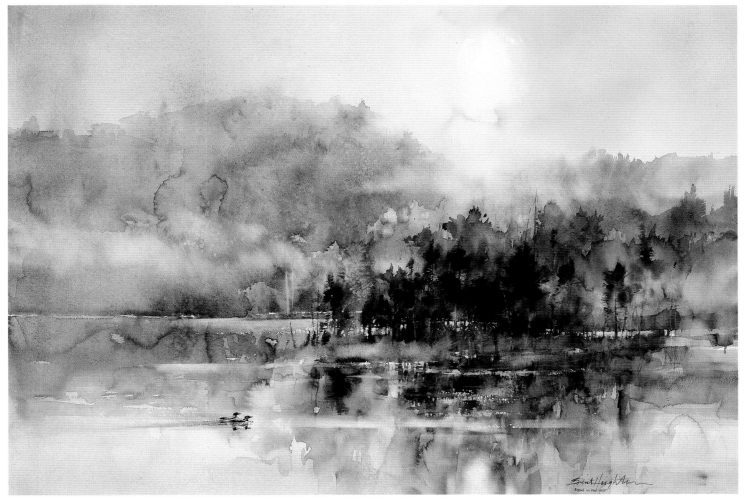

Brent Heighton *Loons in the Mist* 22" x 30" Watercolor

Loons in the Mist was done after a trip to the Catskills and the Adirondacks. The atmosphere was so ethereal, so spiritual;
I watched the mist burn off and smelled the forest. All of this contributed to the essence of the painting.

I followed the drawing, not so much in detail, but in the broad tonal value plan and in the gesture of the pieces of rock.

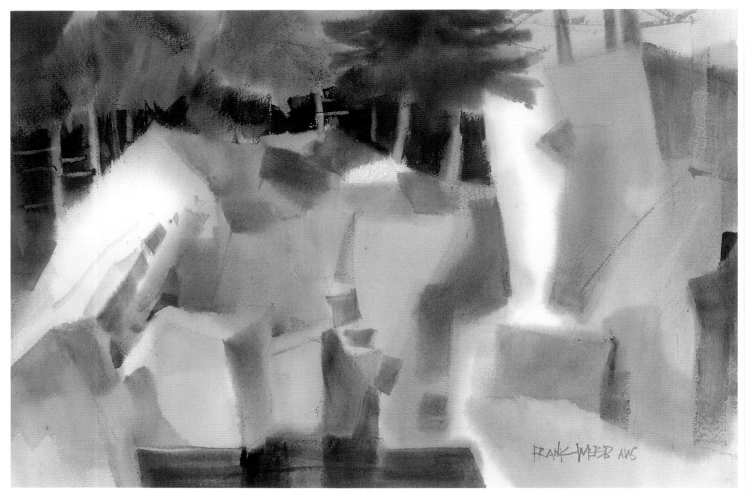

Frank Webb *Abandoned Quarry* 15" x 22" Watercolor

Abandoned Quarry was done in several versions. I painted each by referring to the same on-the-spot sketch. The sketch was a re-creation of observed reality. Most of my composition ideas were tried. I followed the drawing, not so much in detail, but in the broad tonal value plan and in the gesture of the pieces of rock. I limited the colors to cadmium red light and viridian, applied wet into wet. I painted on dry paper with the same two colors but this time I added a little yellow ochre.

It is a very special painting for us.

September Song —

The

Marriage

of

Patricia

and

Norman

September 25, 1993

Patricia Abraham *September Song* 22" x 30" Watercolor

This painting began as a demonstration piece for one of my classes. It presents a loose, intuitive handling of the media with the addition of a few fun techniques. The painting evokes a feeling of joy and passion. My fiancé and I decided to use it on the cover of our wedding program in 1993. We call the painting *September Song* and it became the theme for our entire wedding ceremony. My husband, Norman Van Huff, did the exquisite calligraphy on the program. It is a very special painting for us.

I do watercolor because I love it.

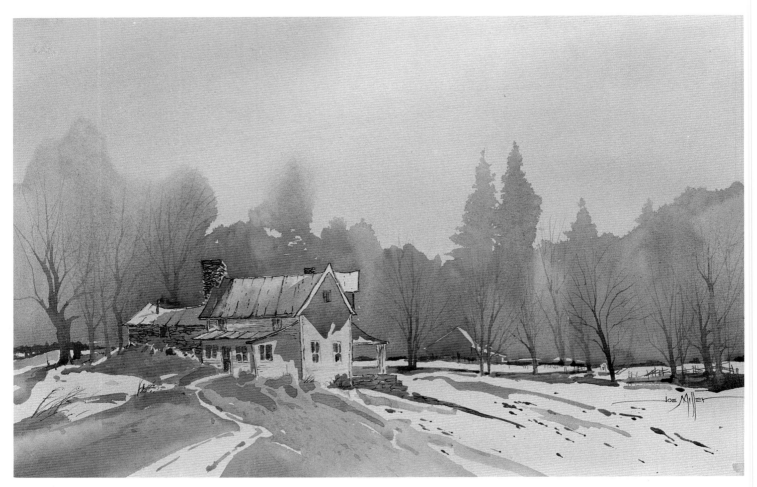

Joe Miller *Nobody Ever Left Aunt Hazel's House Hungry* 15" x 22" **Watercolor**

One of my favorite pastimes is doing watercolor sketches in my journal . . .

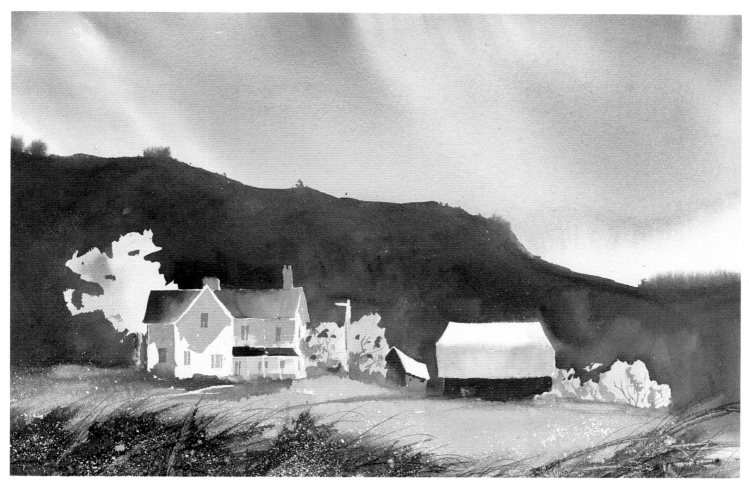

Joe Miller *Blue Ridge Mountains* 15" x 22" Watercolor

I do watercolor because I love it. I even enjoy the frustration and the enormous challenge associated with watercolor. I paint scenes that turn me on, that almost tell me: "I need you to paint me." One of my favorite pastimes is doing watercolor sketches in my journal, accompanied by comments. As a result, I never forget either the feelings I had at the time or the place where the sketch was done. I really enjoy paging through my journal and recalling the times when I did the sketching.

My watercolor journeys led to the development of my business, "Cheap Joe's Art Stuff," which is a real source of creative joy for me. Because of my art supply business, I've had the good fortune to meet many wonderful artists. That's the best part of all!

I will forever marvel at the eternal silence of the woods.

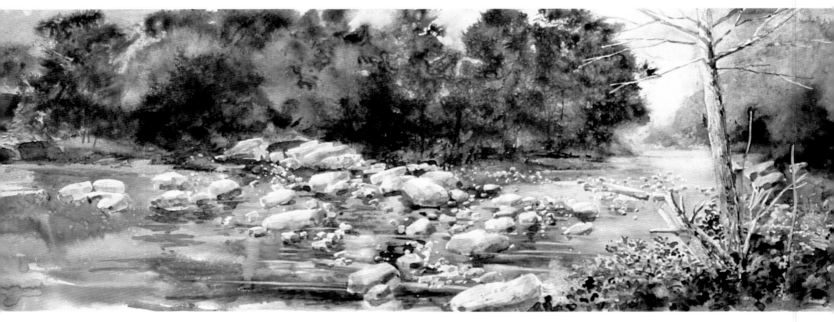

Marc Getter *Woodstock Stream* 11" x 29" Watercolor

 My father died just a few weeks before Chris Unwin asked me to be part of her book. He was a good, kind man and a wonderful artist. He taught art for nearly forty years in New York City.

 Like him, I started to draw and paint when I was very young. Our summers were spent at an old barn converted into a home in Upstate New York. I will always remember the warm, sunny days spent painting next to my Dad. We painted on a porch that looked out into a dense forest. Today, I paint landscapes the same way I did then. I still love old, weathered barns, desolate, abandoned houses, trees, earth, and sky. I will forever marvel at the eternal silence of the woods.

 In going through my Dad's things, I discovered several figure drawings he did when he attended the Art Students League back in the 1920's. They are magnificent full-tone renderings and remind me of the Old Masters. Lately, I've been thinking of adding the human form in my work. I hope these old drawings, coupled with my memories of his encouraging words and presence, may help me tackle this new area with some measure of success. I don't expect it to be easy. Breaking away from what we know and are comfortable with is hard to do, but it's only by exploring new areas that we grow as human beings and as artists.

I'm an experimental painter.

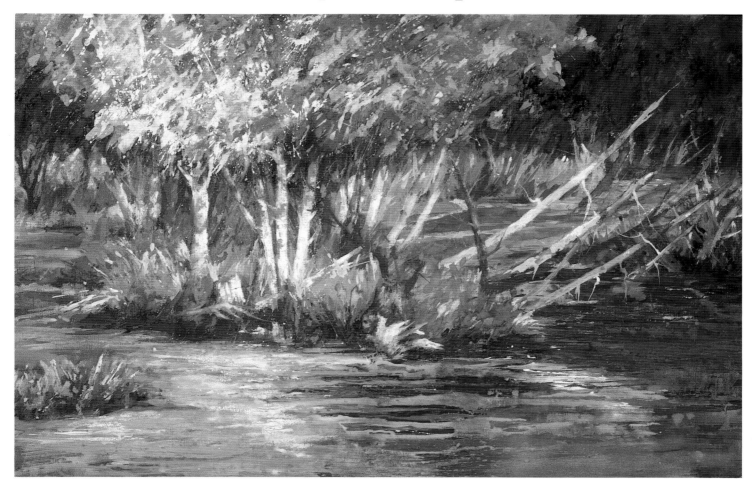

Lena Massara *Really Spring* 20" x 30" Gouache, Pastel, Pumice

I'm an experimental painter. I have worked in several mediums searching for that special texture and form of expression. Whichever medium is chosen, the artist's unique vision is what determines the result. Landscapes and figurative art are my favorite subjects. I keep searching for that "special" texture and form of expression. I use pastels on 300 lb. watercolor paper, four-ply watercolor board and acid-free mat board coated with four coats of gesso and pumice worked wet into wet (thus requiring a rigid surface). The initial surface coat is gouache. A desirable surface coat can be achieved using "hot," "cool" or complementary colors. I use a 2" flat brush or the side of a pastel stick to achieve a loose drawing. A second layer of color is added with soft pastel that I manipulate with brush and water.

In *Really Spring,* a new layer of gouache was applied using a squirt bottle. This helps maintain a liquid consistency to enable the tilting of the surface that causes the colors to mix and run. I painted the foreground with additional pastel highlights after drying. The background trees were manipulated using water, then repainted with watered down gouache. I repeat this process until I achieve the desired result. Repetitions are easy because the surface is very forgiving and the pastels are painted out using water. Trying new techniques opens new pathways to self expression.

The Sea

The late afternoon winter sun lights up distant ledges and surf in strong contrast to the large area in deep shadow.

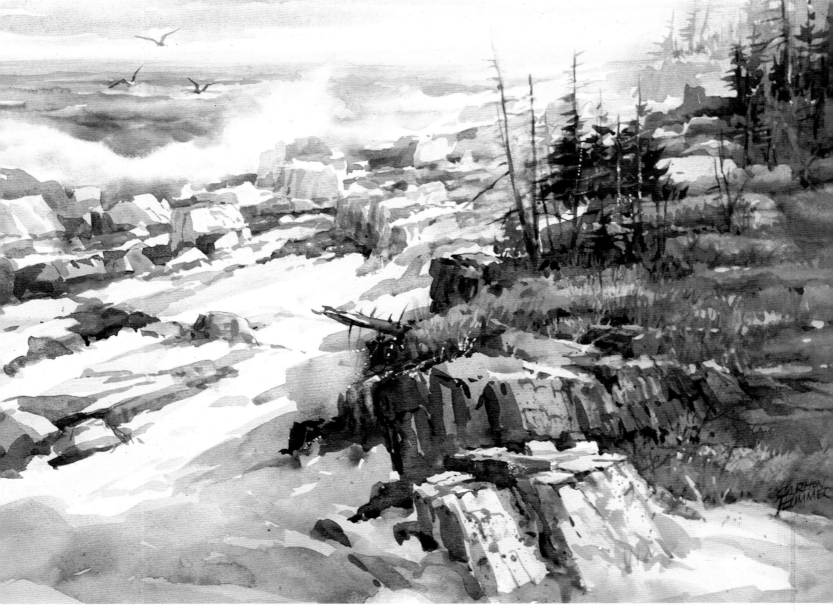

Carlton Plummer *Wintercoast* 21" x 29" Watercolor

 The late afternoon winter sun lights up distant ledges and surf in strong contrast to the large area in deep shadow. Lighting, as in most dramatic situations, is the key to emphasize the mood of the day. The warm color was applied wet on dry to control the delineation of the distant ledges affected by the sun. The cool blues and violets were added wet into wet to create soft edges for depth. I applied warm colors to show through in the shadow area for contrast. The cast shadow on the snow was applied wet on dry and leads the viewer zigzag fashion back into the composition. The vertical trees present a contrast of direction or opposition to the ledges, water and shadows.

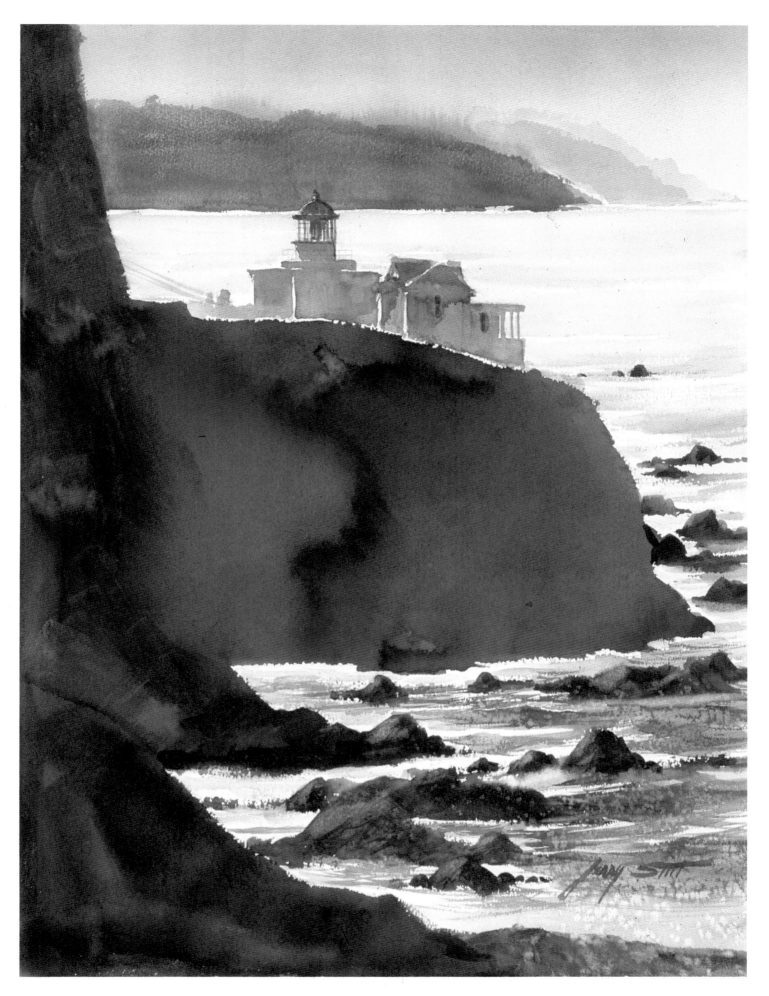

Jerry Stitt *Point Bonita Lighthouse* 18" x 24" Watercolor

35

Nita Engle

Rocks & Sea 20" x 30" Watercolor

I am forever walking on beaches, and enjoy it always. It is most exciting when the weather is dramatic, when sea birds cry, waves crash against rocks and thunder on the shore and the air is filled with spray and sunshine. Then begins the experimenting in my studio, playing with the water and paint, trying to recreate the drama. I painted *Rocks & Sea* with no drawing or planning, just a large reservoir of information gathered over years of observation.

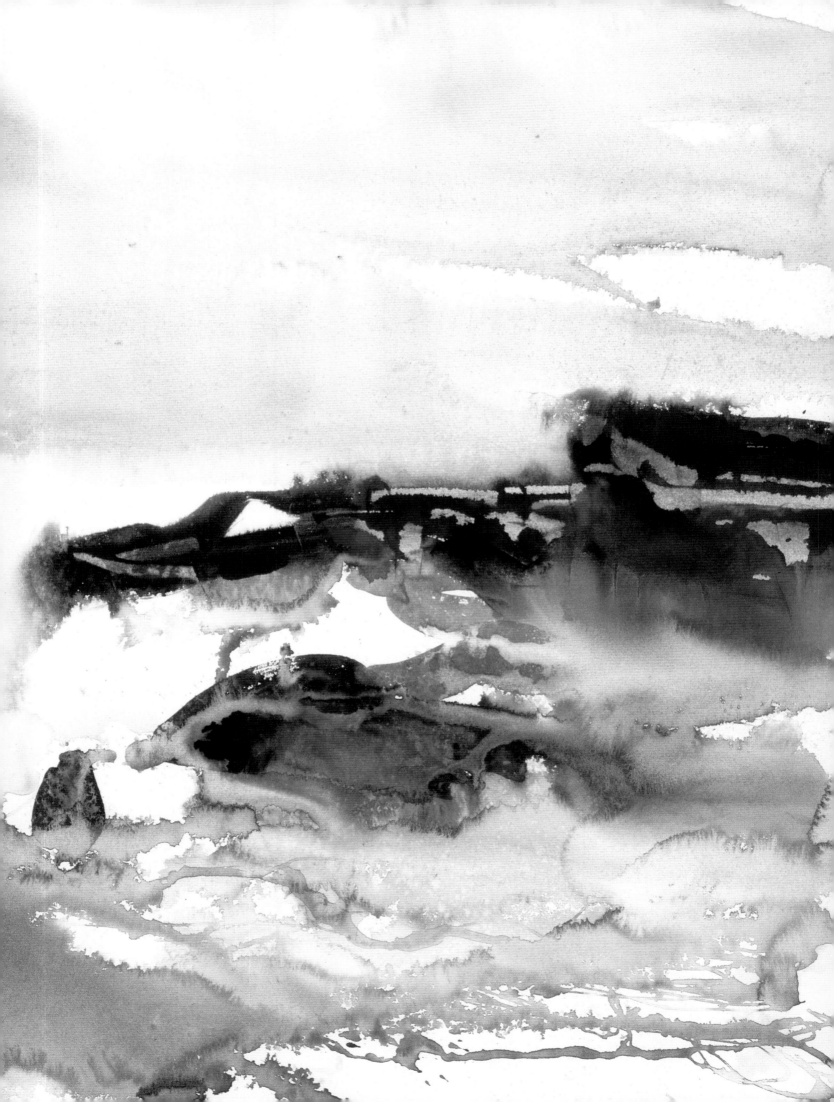

. . . there was a sudden change as the sun burst out
of the clouds and beat down on the water.

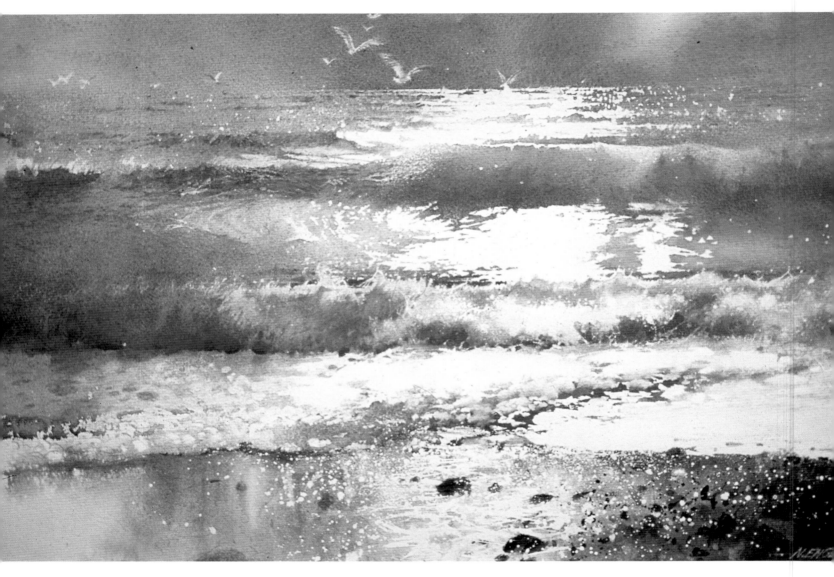

Nita Engle *Beachy Head* 22" x 30" Watercolor

 I was inspired to paint **Beachy Head** while standing on the shore of the English Channel. The atmosphere was dreary and dull; but there was a sudden change as the sun burst out of the clouds and beat down on the water. Because I was there, I not only experienced that moment, but had the opportunity to make first hand observations. For example, the brightest light was on the flat sea, not on the white foam of the breaking waves. I think I would have confused that, had I not seen it personally.

I devote a great deal of attention to values because
they are the foundation of visual contrasts.

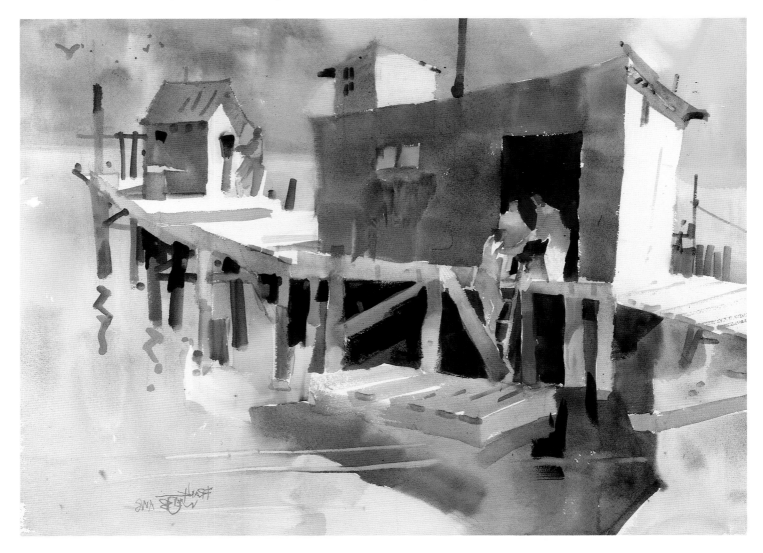

Frank Webb *Port Clyde* 22" x 30" Watercolor

 Port Clyde is concerned totally with broad value shapes. I devote a great deal of attention to values because they are the foundation of visual contrasts. We work in vain if we do not have well-shaped, well-separated pieces of easy reading value hunks. Following my value plan, I elected also to divide my color contrast into oppositions of warm and cool. Arbitrary breaks of color excite the sky and make the blue shack seem to pulsate.

 You cannot communicate images in a meaningful way unless you are genuinely interested. This state of mind and heart must then be dished up in a suitable composition. Composition and emotional involvement are the ends. They are much more important than technique which is the means.

The Sky

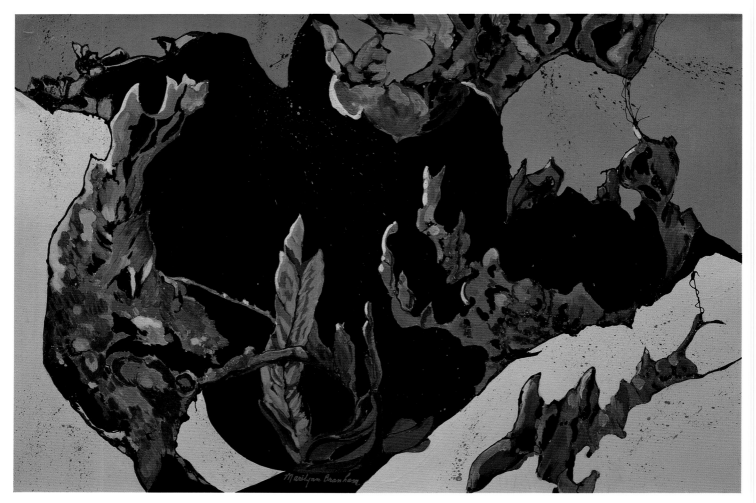

Marilynn Branham *Fall Festival* 22" x 30" Acrylic on Paper

I try to express my fascination with Nature's myriad shapes, colors, and textures through painting. I like to approach the same theme in several different ways by doing a series. The themes I choose relate to Nature, the tactile surface of a limestone bluff, for example, or river water taking its leafy or feathered passengers on their way downstream, or the splendid, time-etched shape of an old tree against the sky.

I start painting with quick sketches from photos, spontaneous brush strokes, runs, or washes of different colors and consistencies. The images are intimate, giving the viewer a peek into a special place they haven't been. I like to enhance the colors for a sense of drama, aiming for good execution and a complete statement. I think of the images as "intimate bits of nature." I'm always excited when asked to participate in an exhibition. I start thinking of all the wonderful images I will attempt, realizing I may not always succeed. What a great way to begin!

To stimulate creative thought, I go to the countryside with my camera. I visit beautiful nearby rivers, the huge granite outcroppings or the limestone bluffs near my home in Ingram, Texas. On these excursions I look for dramatic abstract shapes; for the specific point where I find the greatest value contrast. Even the layers of rock that have been cut away for highways are splendid examples of light and dark values. After one of these excursions I can't wait to start painting.

I started painting ***Fall Festival*** by flinging paint in a circular movement. It is reminiscent of the curled, dead leaves of the sycamore. The sycamore leaf with its wonderful rhythmic shapes seems to dance in defiance of the floods and winds of fall.

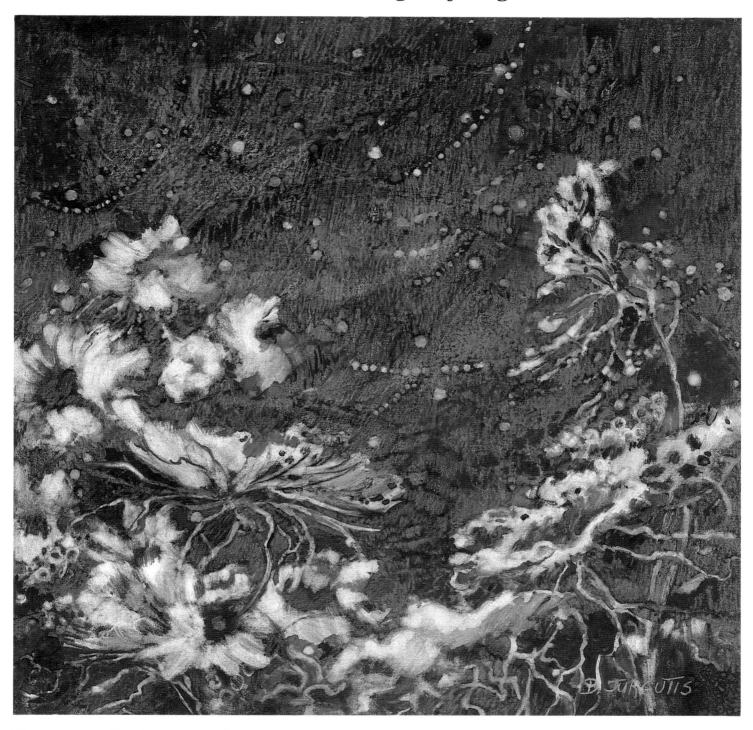

Danguole Jurgutis *Starry Night* 20" x 30" Mixed water media

When I first heard Don McLean's song *Vincent*, sometimes called *Starry, Starry Night*, it made me cry. It made me want to do some paintings that evoked the magic of night, and honor the tragic Van Gogh.

To express the mystery, the magic of night as seen by the mind's eye, I developed a new and special technique. The main approach is the removal of paint; this will expose the previously stained surfaces that are lighter than the original. I go back and paint into these exposed areas, over paint with tempera, remove and paint again, and again. I use water-based paints in this technique: watercolor, acrylics, tempera, inks and Caran d' Ache crayons and pencils. The surface is gesso primed watercolor paper. Sign cloth can be used also.

I intended *Starry Night* to evoke the feeling of night, of starlight. To do so, I combined realistic references of nature with abstract, invented fantasy forms and invented colors. This technique produces a very rich, multi-layered, unique surface.

A cornfield suddenly becomes a cosmos of color blowing in the breeze.

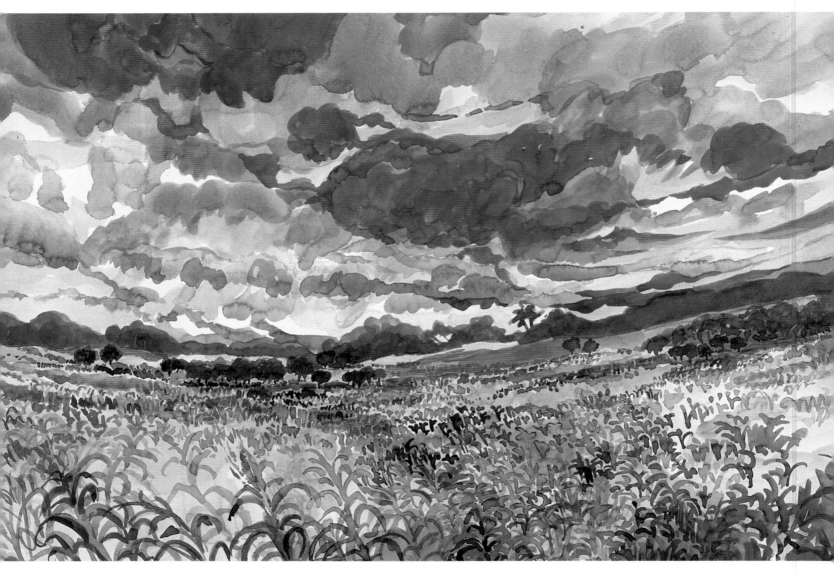

Gwen Tomkow *Cornfield Cosmos* 22" x 30" Watercolor

Every artist has a unique palette. I use the colors of my palette intuitively; they express my personality. I use transparent, bright color to give my work the energy and emotion I feel when painting a northern Michigan landscape.

I feel a spiritual connection with the earth taking place when I'm painting on location. Peace of mind and joy in my heart give me a sense of freedom. A cornfield suddenly becomes a cosmos of color blowing in the breeze. Clouds turn into rolling, tumbling, frolicking entities, adding to the majesty of the sunset. Light shimmers across the water as it moves to the shore. Warm and cool colors weave and dance back and forth to form a shimmering pattern everywhere, Mother Nature's quilt of many colors.

Spontaneity is the key to my impressionistic style; therefore, I give myself permission to use my imagination to interpret landscape as I want it to be, instead of the way it is. I create fantasy saturated with color. I still get a thrill when the result works. I'm amazed and delighted with the creative process.

There's a sense of magic, a sense of being lifted into another world, like dancing down that "yellow brick road."

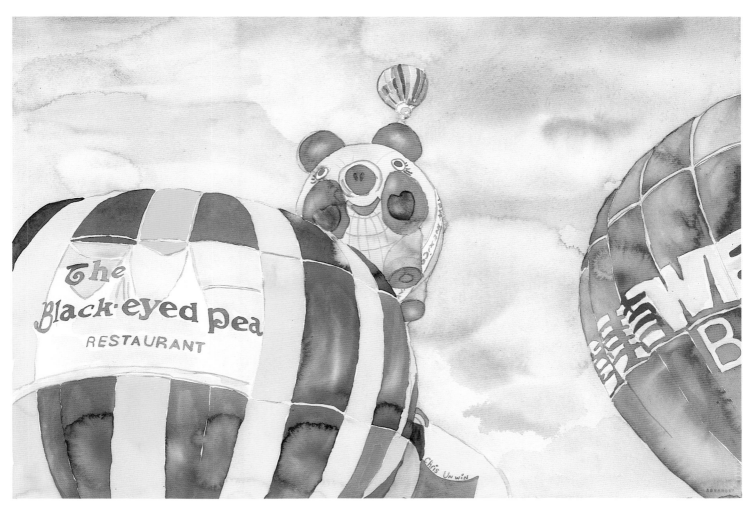

Christine M. Unwin *Balloon Fiesta* 22" x 30" Watercolor

I could have titled this painting: *On the Way to Santa Fe*. I stopped at the Balloon Fiesta in Albuquerque, New Mexico, while on my way to teach a workshop in Santa Fe. It was positively inspiring, like being Alice in Wonderland. There's a sense of magic, a sense of being lifted into another world, like dancing down that "yellow brick road." I executed a series of paintings featuring the balloons, full of riotous color and playfulness.

The Southwest

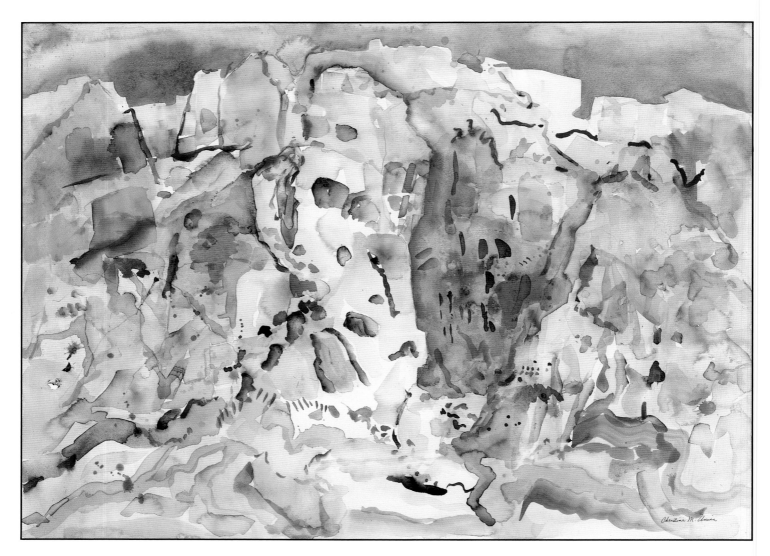

Christine M. Unwin *Bandelier National Park* 22" x 30" Watercolor

I took my Santa Fe workshop students to the Indian cave dwellings at Bandelier National Park. I tried several times to do a good painting, without success. This painting was my last attempt. For whatever unexplained reason, I decided to just "blast out a quickie." It was totally spontaneous, and done without much conscious thought. I reacted to the subject in a very emotional way. It was so hot and I was so tired, too tired to think. I finished the painting in my studio, where I really struggled with the dark areas, putting them in and removing them over and over. I finally reached a resolution by adding even darker accents.

I felt the painting really worked and displayed my own "artistic touch." I was delighted later to have this painting juried in to the Springfield Art Museum's 1994 Watercolor USA show.

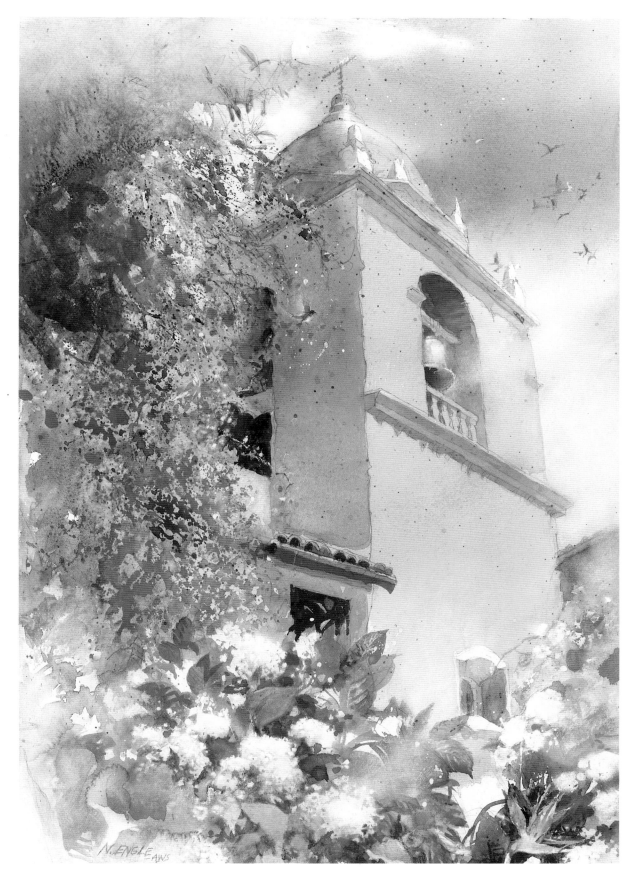

Nita Engle *Bell Song* 22" x 30" Watercolor

 Bell Song required on-the-spot planning. I was teaching a watercolor workshop in California. The whole class was roaming around the mission and court yards. Everyone was responding in a different way — some to the flowers and fountains, others to the architecture — but all living in the golden atmosphere of the present moment. I could not have painted this watercolor if I had not felt the silence, if I had not heard the drone of the bees, the occasional silvery peal of the mission bell and felt the peace and serenity of those walled-in gardens.

I try to touch a chord in the lives of those who have never traveled to this enchanted land.

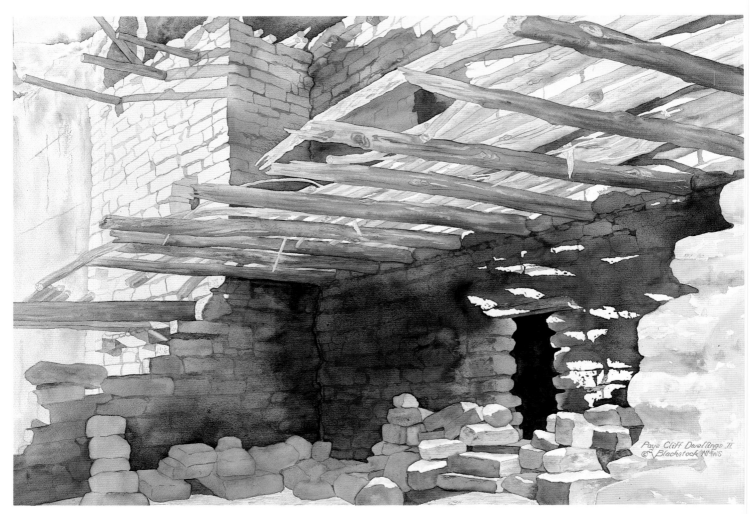

Virginia Blackstock *Puye Cliff Dwelling II* **29" X 37 Watercolor**

. . . they are sign posts to our past . . .

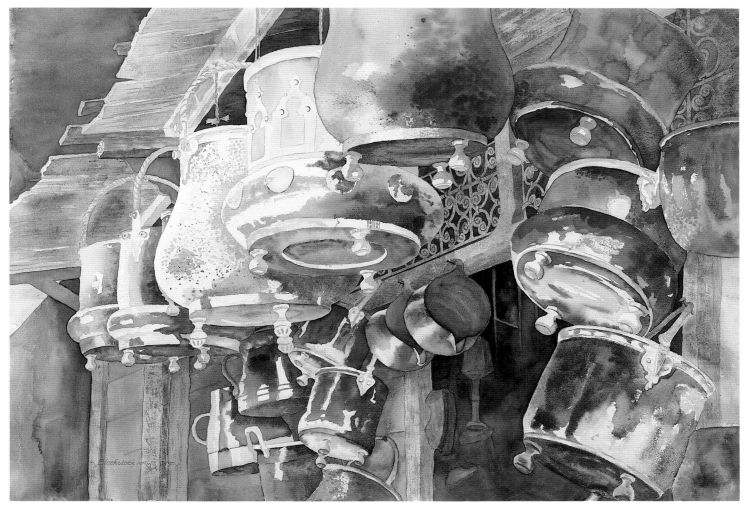

Virginia Blackstock *Copper & Brass II* 20" x 26" Watercolor

I try to mix a powerful design; one affected by light and shadows, with technically accurate renderings of historic places and objects, such as rock art and ruins. It is important to do so to teach their value as part of our history and for their preservation for further study. Just as Berstadt's paintings created interest in the preservation of our beautiful National Parks, so has rock art raised the level of interest in preserving Anasazi, Fremont and sites of other ancient art and dwellings.

I'm easily inspired to paint them because they are sign posts to our past and still valued by those of us whose lives they have touched. Patterns, colors, textures — all call upon my skill to imbue these ideas with life. An unusual perspective on a usual scene gives impetus to my intended action and lends power to the painting.

The negative area or background becomes as crucial to the composition as the shadows. Sometimes a spectacular shadow is the inspiration. Sometimes I'm challenged to capture the feeling of tranquility by depicting the strong light on the white rock faces drenched in the sun.

I try to touch a chord in the lives of those who have never traveled to this enchanted land. I try to create an echo of the past, and to instill a desire to see these scenes first hand. My sense of history deepens when I backpack and paint the paths of the Anasazi. I'm taken into ancient cultures and I gaze upon the antiquities of a bygone era. I discovered a sense of kinship while creating these paintings.

It is my interpretation of an awesome subject.

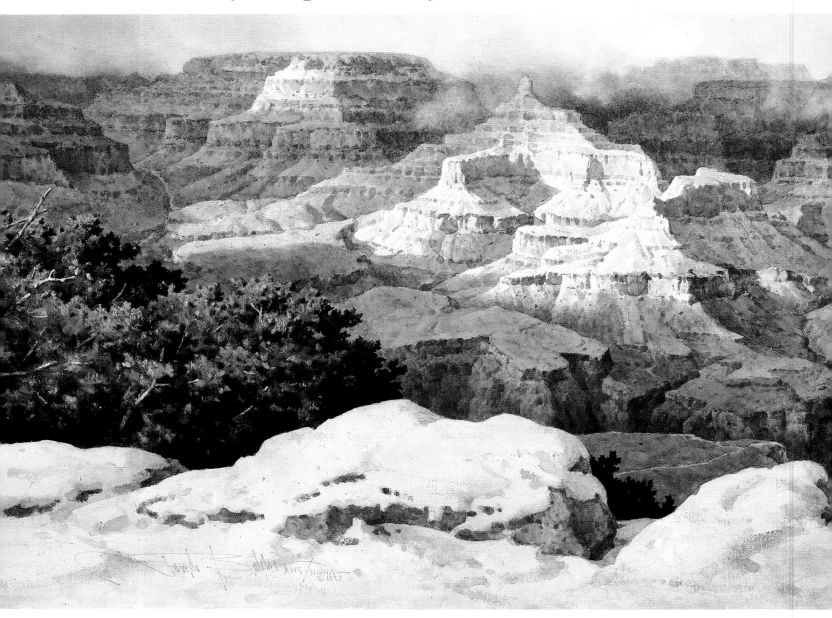

Joseph Bohler *February Snow Showers — Grand Canyon* 30" x 40" Watercolor

When I first saw this view of the Grand Canyon's south rim, I knew I would have to simplify the landscape. I tried to use the clouds, snow showers, sunlight and shadow to my best advantage. I was inspired by the sunlight breaking through the clouds. It caused a spot lighting of an area and a focal point with crisp edges. The snow showers and shadows were contrasting and seemed to simplify and soften the edges and other shapes. The Grand Canyon paintings of Wilson Hurley and Clark Hulings were definitely my inspiration for this painting. It is my interpretation of an awesome subject

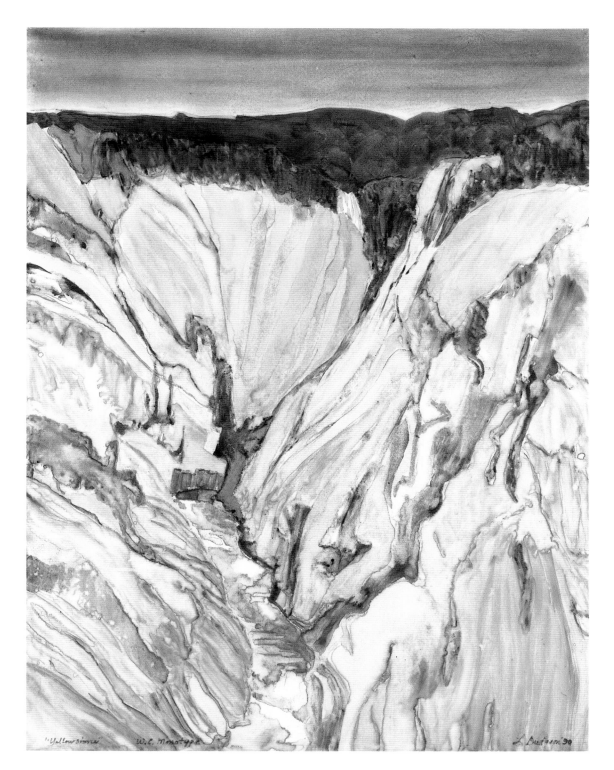

Lily Dudgeon *Yellowstone* 22" x 29" Watercolor Monotype

 There's a mysterious quality about watercolor monotypes. It goes beyond the beauty of pigment painted on paper. Dark edges creep in unannounced. Some colors print vividly, some do not. Hand printed monotypes are impressionistic, Seurat-like. The unexpected results make every print pulled a surprise — as exciting as opening presents at Christmas. The process fascinates me. It challenges me to learn how to control most, but hopefully not all, of the "accidents" that occur in the process.

 I became addicted to monotypes in 1981 at the Oxbow Center for Fine Arts in Saugatuck, Michigan. The Center offers facilities for painting, ceramics, paper making, and print making. I watched an artist making monotypes and asked if I could do the same with watercolors and avoid the toxic solvents usually used for monotype cleanup. "Sure," he said, "I'll show you how." That was it. I was hooked; it changed my life.

 I returned to night school to work on my art degree. Later, after retiring, I went to school full time. The classes included watercolor monotypes in a directed study program. I even bought my own monotype press. Before long, I began teaching monotype workshops at two local art centers. My interest in art flowered late in life, but I thank God for the beauty and joy art has given me.

I tried to blend a still life scene seamlessly into a landscape of the Rio Grande River and the mountains of Mexico.

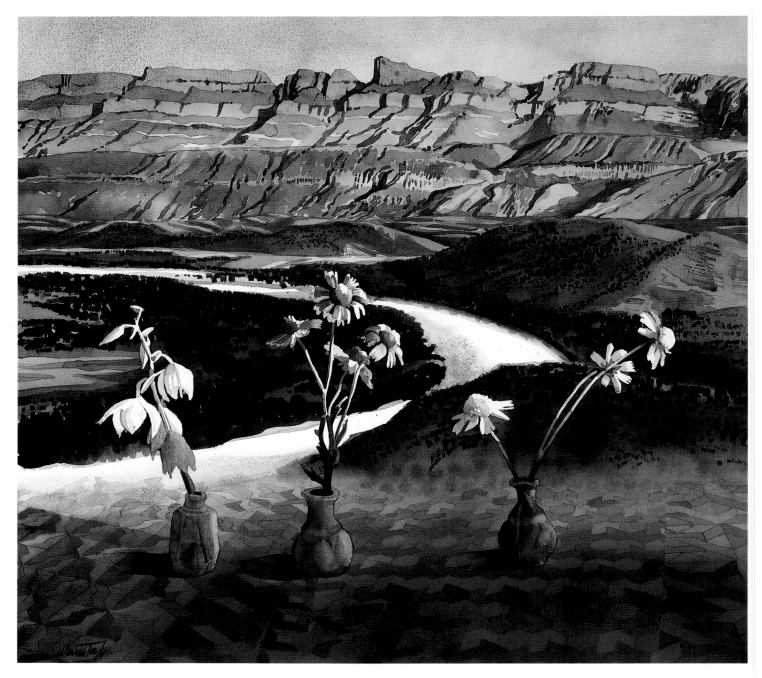

Warren Taylor *Big Bend Shadows* 40" x 60" Watercolor

. . . the agave plant . . . serves as a hardy reminder
of the permanent beauty we see in nature.

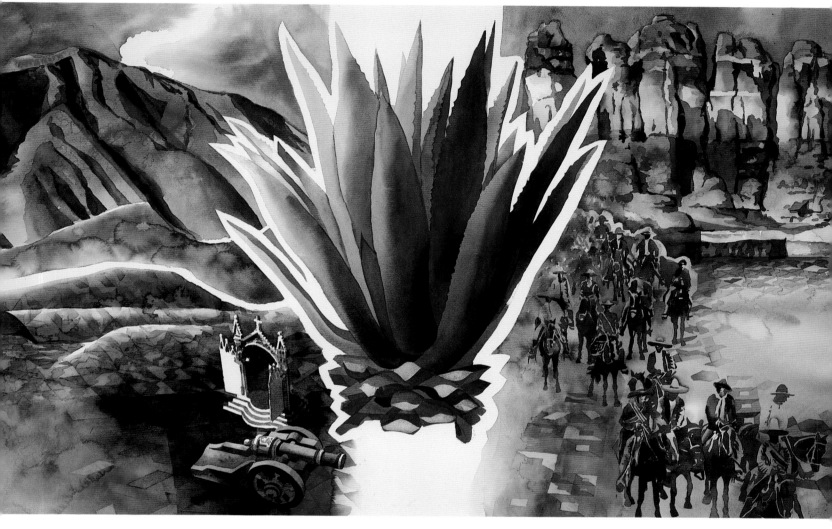

Warren Taylor *Boquillas Agave* 20" x 24" **Watercolor**

For years my work, produced in various media, centered on fine-focus still life subject matter. My struggle during this time was to keep my work free of the direct influence of other still life artists. I wanted to give my own interpretation to objects and settings based on my own life experiences. This idiom, this style of artistic expression, served me well. As a result, I have received awards and opportunities to present exhibitions of my work.

Some time later, I felt that the close, precisionist space that I was using in my work was having a claustrophobic effect on me. I needed a breath of fresh air. I decided that only a direct reference to landscape could fill this need. I wanted to breathe the air and experience the atmosphere of the domain where I live, the Southwest.

Big Bend Shadows was one of my first works in this new direction. I tried to blend a still life scene seamlessly into a landscape of the Rio Grande River and the mountains of Mexico.

Boquillas Agave is another example. The painting shows a direct reference to landscape with segments pieced together in collage form. The references to Southwest history, geography and local objects are bound to and dominated by the central object, the agave plant. Throughout a history marked by the shifting influences of various political and religious forces, the agave plant has remained constant in the Southwest, has survived and serves as a hardy reminder of the permanent beauty we see in nature.

Animals

I discovered the dramatic beauty and power of those extraordinary wild animals

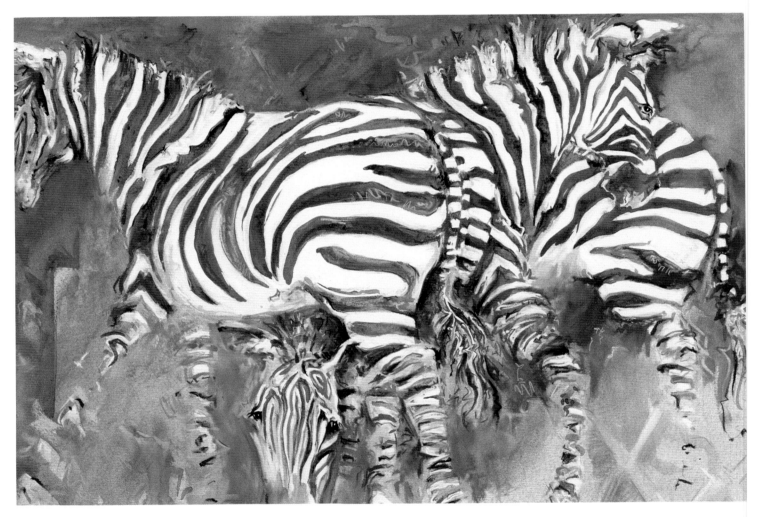

Marsha Heatwole *Punda Milia Kuja Na Kwenda* 18" x 24" Mixed Media over Monotype

Although my work revolves around print making, I also use elements of drawing and painting. I begin with the traditional subtractive method monotype; this involves applying black etching ink to a plexiglass plate and manipulating the ink — mostly through erasure — to create an image. This black and white image and its "ghost" are then transferred to separate sheets of damp paper with an etching press and allowed to dry. Using watercolor, I can advance or relax areas of my composition in each monotype. Then I specifically sharpen, soften, invigorate, and give "punch" with chalk pastel, gouache and prismacolor pencils. Most importantly, I feel I must preserve the integrity of the underlying monotype.

I am also greatly concerned with upholding the integrity of my subject matter. After studying and living with American domestic animals for years, I traveled to Africa, where I discovered the dramatic beauty and power of those extraordinary wild animals.

Marsha Heatwole *Twigas* 18" x 24" Monotype

53

Mary Hickey *Cats, O Glorious Cats* 22" x 30" Watercolor

Not long ago, a wonderful calico cat called "Whiskers Marie" came into my life. My love for cats and painting blended. I delighted in the luxury of a live-in cat model. I could express my sense of humor. My love for painting became a passion. A "cat painting" series evolved. There was: "Reclining Nude" — Whiskers Marie stretched out wearing only a necklace. It was followed by "Nude Sunbather" — Whiskers Marie grooming herself and basking in the morning sun. Because I painted her so many times, I realized I had the equivalent of a "Helga" show. I even produced "Whiskers Marie Helga Hickey," in the famous turtleneck pose. I then moved beyond my live-in cat model to the Humane Society cats and from there to the cat shows to paint the "rich and famous" cats. Later I viewed these paintings and the sharp contrast of the "poor and homeless" cat paintings with the "rich and famous" cat paintings as mirroring the social classes that continue to divide people in our society today.

A quantum leap was made. I was in a different place as an artist. I continued to paint in series, but now focused on floral paintings. But I no longer just painted magnolias, magnolias now seemed to demand to be painted, followed by the irises, then the poppies. Of course, I introduced my "new friends" to my "old friends'" by combining the flowers with my cats.

Art work is my energizing force. I was recently asked to describe my work as an artist. I replied: "It's whimsical in nature, vibrant in color," a line I'd heard others use when referring to my work. I try to lift the viewer's spirit, to coax a whimsical smile on an otherwise gray day.

*. . . a wonderful calico cat called "Whiskers Marie"
came into my life.*

Mary Hickey Whiskers Marie Helga Hickey, 15" x 22" Watercolor

*I try to lift the viewer's spirit, to coax
a whimsical smile on an otherwise gray day.*

Mary Hickey *Victorian Cat* 22" x 30" Watercolor

*Artists sharing with other artists has been
my greatest source of learning.*

KiKi Styke

Cat in the Bag 15" x 22" Watercolor

 My paintings are inspired by the people in my life, by places I've traveled to and, of course, by my two faithful companion cats, Gizmo and Chin Chin. Great models. Each day is a process of learning about people, places and things. The magic and happy surprises of the watercolor media make it my favorite way to express my spiritual love of life and the wonders of this little star we live on. Artists sharing with other artists has been my greatest source of learning. Classes, workshops, and world travel inspire my work with a passionate desire to see more, learn more and paint more

 Cat paw prints on a fresh wash become a real challenge to camouflage in a painting and so much fun to turn them into happy accidents.

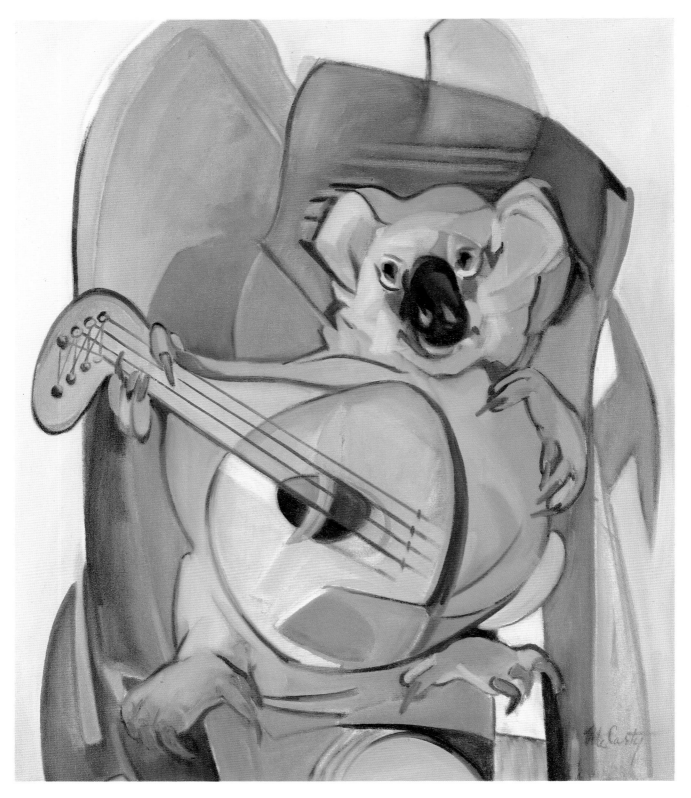

Lorraine Chambers McCarty *Guitar with Bear* 20" x 24" Oil

The outrageous design of a purple koala bear playing a guitar in an over stuffed chair tickles my fancy. The en camaieu (under painting in a single color) painting establishes my value and shape relationships. Repetitions of shapes and reversals of negative and positive areas are always high on my list during the design stage of my paintings.

I used split complements over the under painting. A complement is opposite on the colour wheel — blue-orange, red-green, yellow-violet. Split complement means using the colours on either side of the complement. I used orange for the guitar which is the direct complement of blue. Therefore, I used purple and green which are adjacent to blue on the colour wheel. I made each stroke interesting with slight variations in colour using warms against cools of the same hue. Then, I move through the palette changing colours so that there is always something new to discover in every area.

Buildings

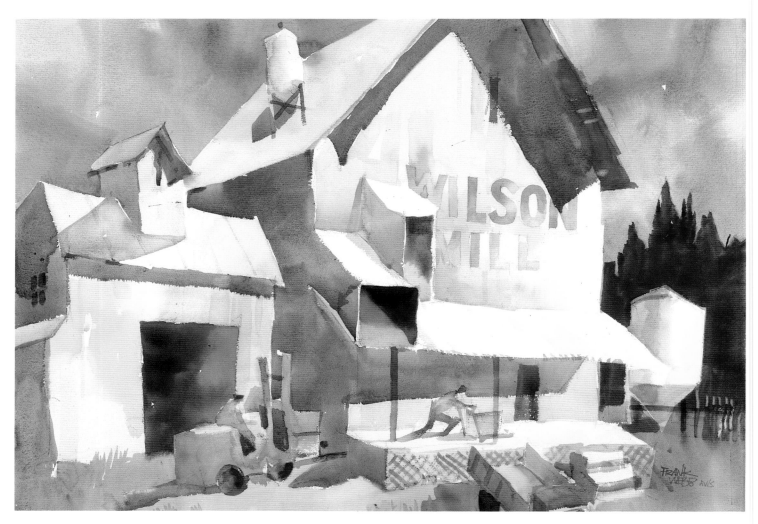

Frank Webb *Wilson Mill* **22" x 30" Watercolor**

 I painted *Wilson Mill* by flowing the paint onto wet paper, using soft squirrel hair flat brushes. My color aim was to intermingle warm and cool color throughout while maintaining separation of large cools against large warms.

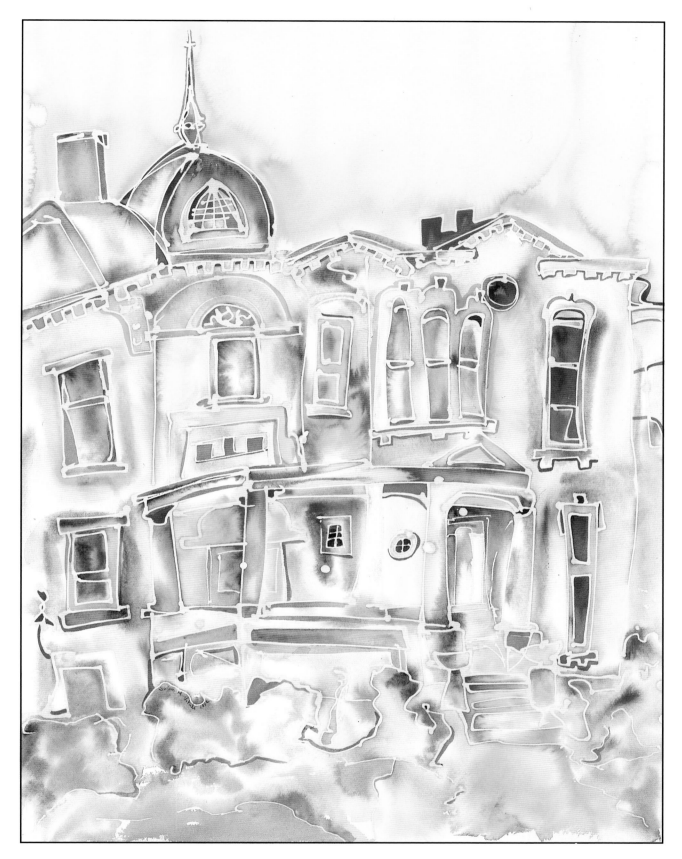

Susan Vitali

House Series # 4 **22" x 30" Watercolor**

I strive to express a unique style, to be myself, to be original. Color is very important. It conveys a feeling of joy.

Recently, a group of artists viewed a slide show of my work. They had many wonderful things to say which really "pumped me up." As a result, I was charged with positive emotions when I painted "House series # 4." I paint best when I'm charged with emotion.

"House Series" began when I lived in downtown Detroit while attending Wayne State University. Many neighborhood buildings were falling apart. It was very sad to see these beautiful old homes just rotting away. I wanted to show Detroit in a positive light. The series has helped me accomplish this goal. I've since added houses and buildings from other Michigan cities.

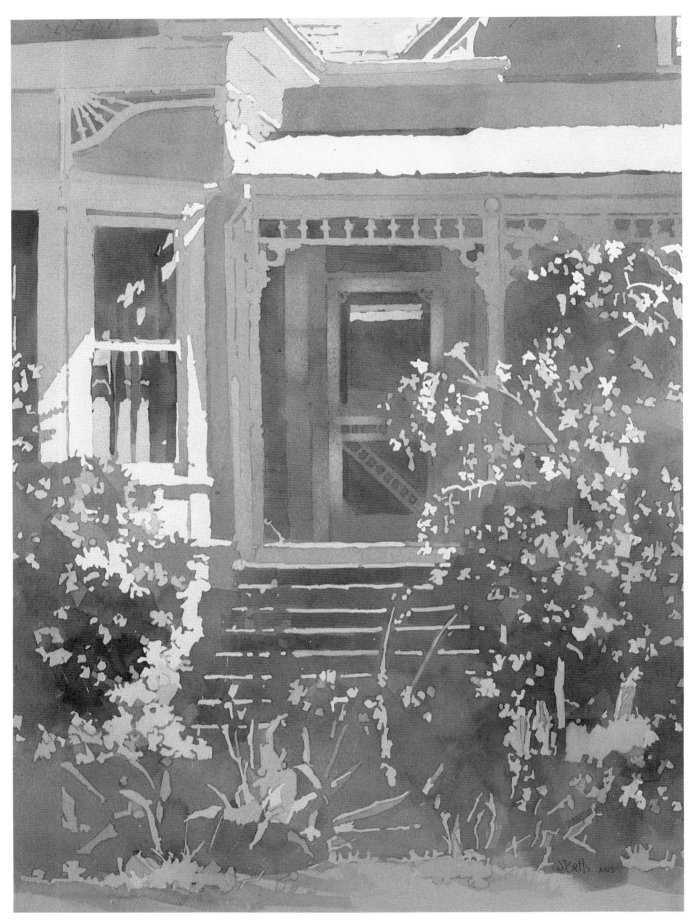

Judi Betts *Sunshine Serenade* 22" x 30" **Watercolor**

The warm dominance throughout this painting makes the smaller cool areas pulsate with a variety of greens.

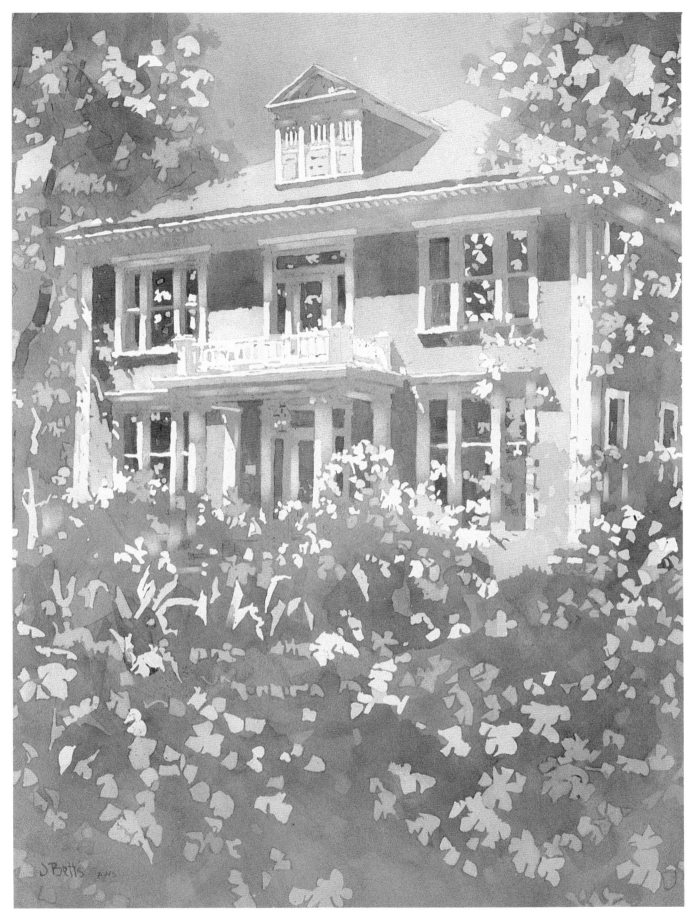

Judi Betts *On the Sunny Side of the Street* 22" x 30" Watercolor

Note that there is a "U-shape" of green. The warm under painting makes the picture seem to glow. In the lower right corner are a few rich, bright, clear greens to convey the illusion of extensive gardens.

To truly depict the essence of a subject, I spend many hours painting directly — either in the field or in a familiar place.

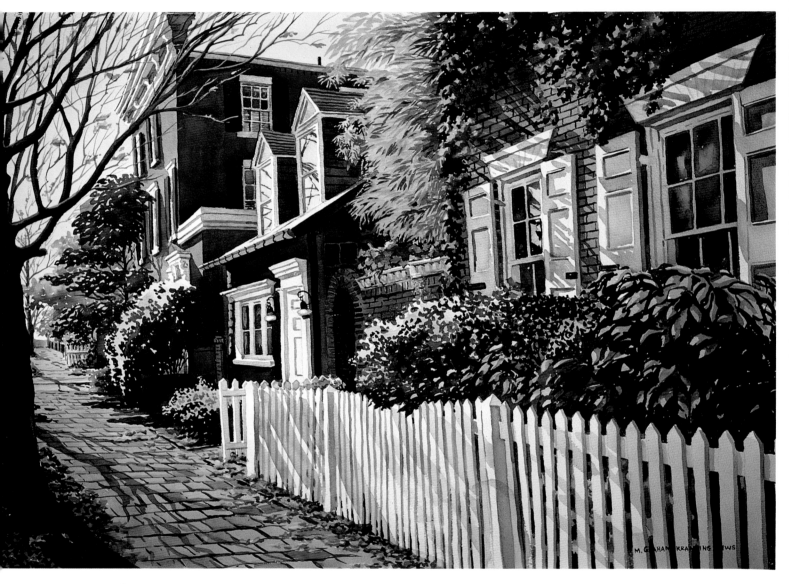

Margaret Graham Kranking *Autumn Morning, Georgetown* 22" x 30" **Watercolor**

The light was so perfect on Kimberly's Nest
that I had to sketch it on the spot.

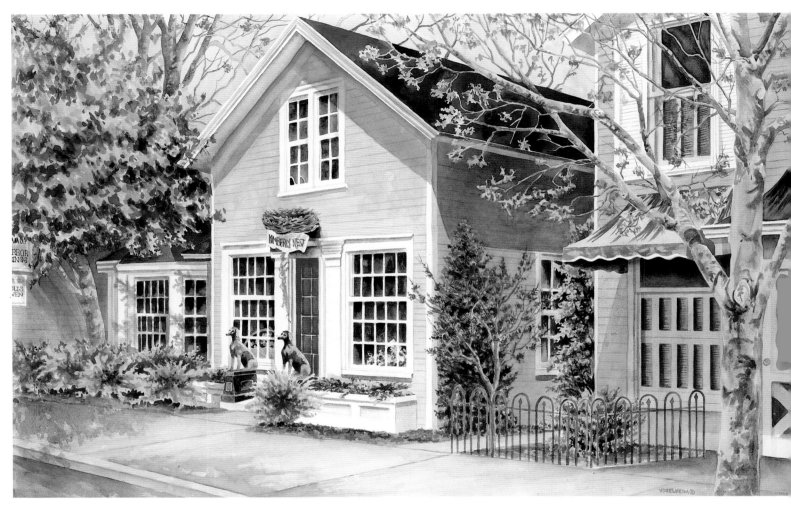

Donna Vogelheim *Kimberly's Nest* 26" x 41" Watercolor

The first principle I stress when teaching composition is choosing a subject to paint that causes some emotional reaction. Something about the subject should elicit an emotional or intellectual "Wow!" I have that response every time I see Little Traverse Bay when I drive down the sloping road to the northern Michigan resort of Harbor Springs. It is such a treat to see the Victorian summer places with their gingerbread trim. The flowers spill out of the window boxes and planters, long covered porches are peppered with white wicker chairs and always the bright azure of the bay! As I walk down the sun-drenched streets, I am mentally creating each new painting, visualizing each new building in my own palette. The light was so perfect on *Kimberly's Nest* that I had to sketch it on the spot.

*I will always remember the warm, sunny days
spent painting next to my Dad.*

Marc Getter *House Doorway* **22" x 30" Watercolor**

Still Life

I began to do watercolors to work faster and to open up the mark.

Janet Fish *Sentinels* **30" x 41" Watercolor**

 Watercolors are a later development of my work in oils. In fact, I avoided watercolor in the past. I believed watercolor was good for bravura performance, but not as good as oil for the development of ideas because it is very difficult to alter a mark once made. One cannot see the result of small changes and this discourages the working out of complicated visual ideas.

 Nonetheless, because I was beginning to feel that my work was losing vitality and becoming too subject-oriented, I began to do watercolors to work faster and to open up the mark. The medium enforces a quickness of thought, and it did work for me. I discovered that I could move more rapidly through the process of selecting and discarding ideas. In the end, I found a looser technique that allows me to break through forms to better integrate the painting. Now I am interested in translating the quick fluid mark characteristic of watercolor back to oil, bringing me full circle.

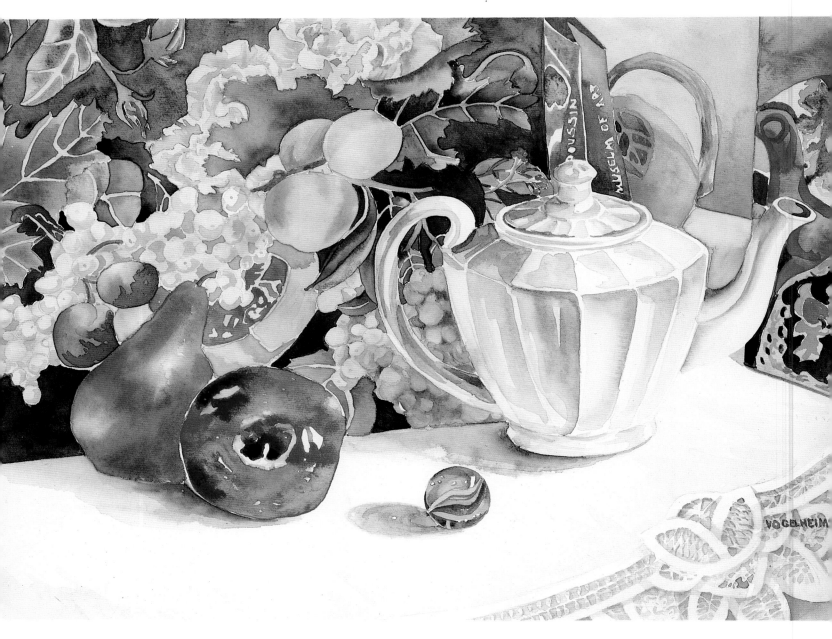

Donna Vogelheim *Tea & Fruit with Old Bags* 11" x 15" Watercolor

My paintings often depict an intimate corner of my world, cherished objects which can be used repeatedly with a slight variation of theme or position. *Tea & Fruit with Old Bags* includes a favorite teapot, collected bags, and a wonderful bit of lace. Also, it includes what appears in almost all my paintings, one or several of the marbles that my sons used to play with over 15 years ago.

I use color vividly to set off or focus on the centers of interest; the warmly painted patterns are used to draw the viewer into the intimate details of the painting and create a path for the viewer to follow.

"where did you get those crazy socks? . . ."

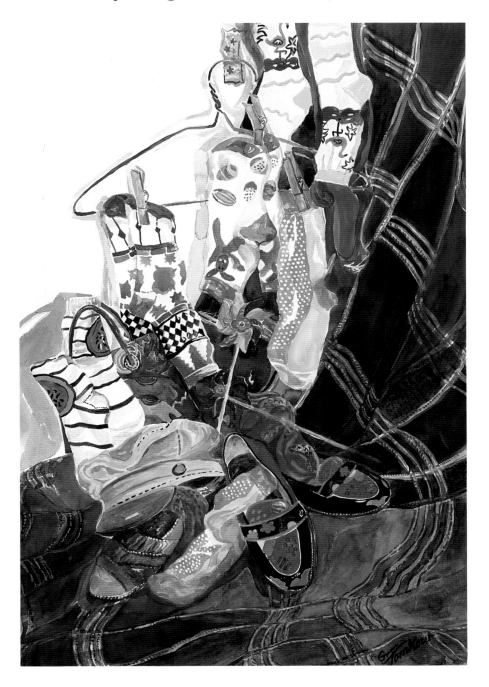

Gwen Tomkow *Crazy Socks* 28" x 36" Watercolor

Recently at one of my landscape workshops, an artist remarked, "where did you get those crazy socks? Cows, flamingos, fish and watermelons. Really, Gwen!" It was a great ice breaker, an example of the subject easily dictating a painting. I told them this story.

Several years ago, I took my annual trip to northern Michigan with a group of artists. I was recuperating from knee surgery, but I was still determined to paint. To keep my spirits up, I bought some colorful, baggy pants, and some outrageous socks. I kept my friends in stitches as I unveiled my footwear each day.

I thought, These socks are so much fun. Why not paint them? I searched for objects that would add a variety of vertical and horizontal shapes. I chose clothes pins, hangers, colorful patent leather shoes, a chartreuse hat and a handbag from India. I made careful use of negative spaces, leaving white paper, and allowing shadows to give depth to the composition. A black and green plaid cloth with red stripes tied it together.

Whenever I see a pair of unusual, crazy socks, I can't resist buying them. I'm now a collector. Friends give me their recent discoveries. (You can see the fringe benefits). These fancy coverings for the feet have spurred me on to the completion of several "crazy socks" paintings. The first *Crazy Socks* was juried in to the Oklahoma Watercolor Society exhibit. I'm definitely having a good time with a simple subject.

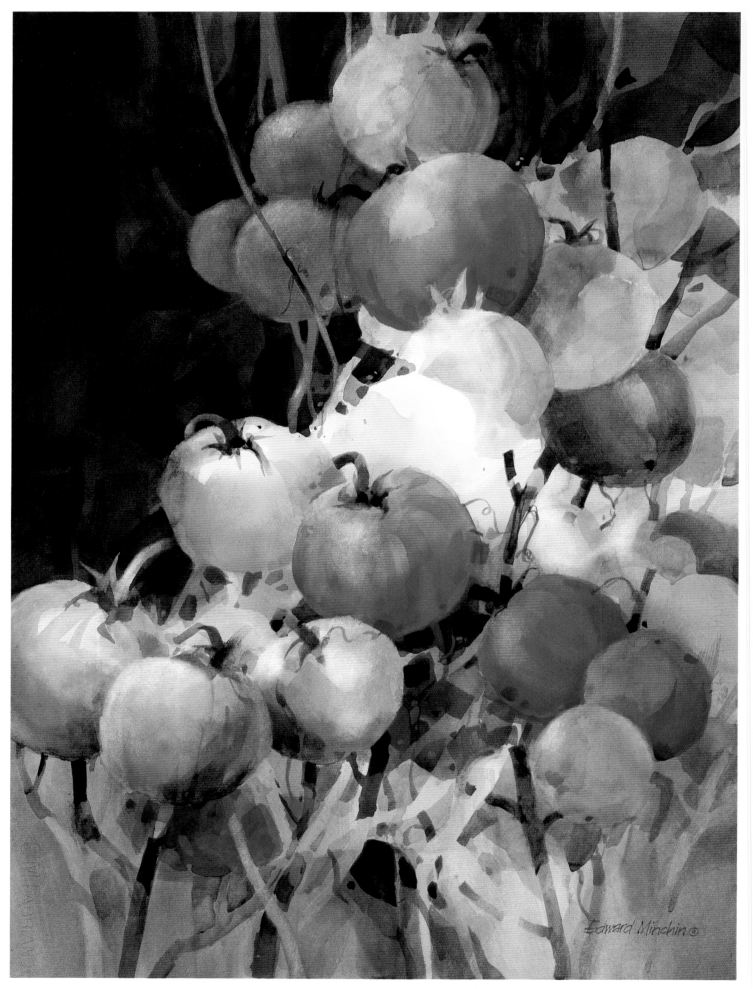

Edward Minchin *Tomato Time* 21" x 28" Watercolor

Boats

*It was covered with rust, had layer upon
layer of chipped paint . . .*

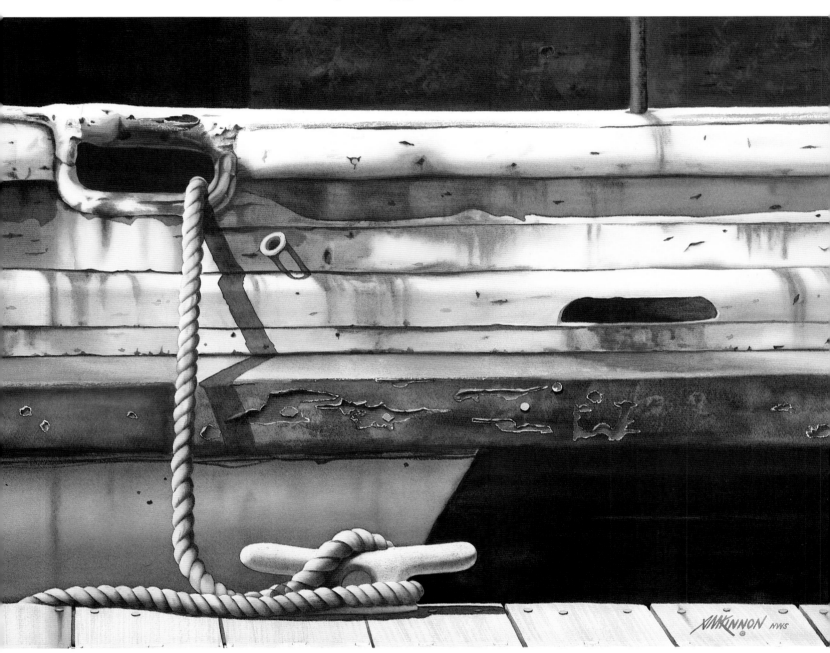

Susan McKinnon *Portside V* **22" x 29" Watercolor**

Several years ago, I spent some time on the docks in Newport on the Oregon Coast where I photographed a wonderful old fishing boat. It was covered with rust, had layer upon layer of chipped paint and had been recently rescued from "the deep" by the U.S. Coast Guard. It was definitely beyond repair, but loaded with character.

Since then, off and on, I've been working on a series of paintings based on those photos. All the paintings are of the same boat, just different sections. I wanted to give the feeling of the boat without depicting it as a whole. I've done this frequently with floral images, and thought it might be interesting to try the same approach with a different subject.

I view these paintings as abstracts. Since a variety of textures attracted me to this boat in the first place, I wanted them to play a key part in the paintings. By keeping the design simple and the palette very limited, I was able to apply the textures and create a bold statement.

I dramatized the sunlight and shadow by exaggerating the warm tones of the sand . . .

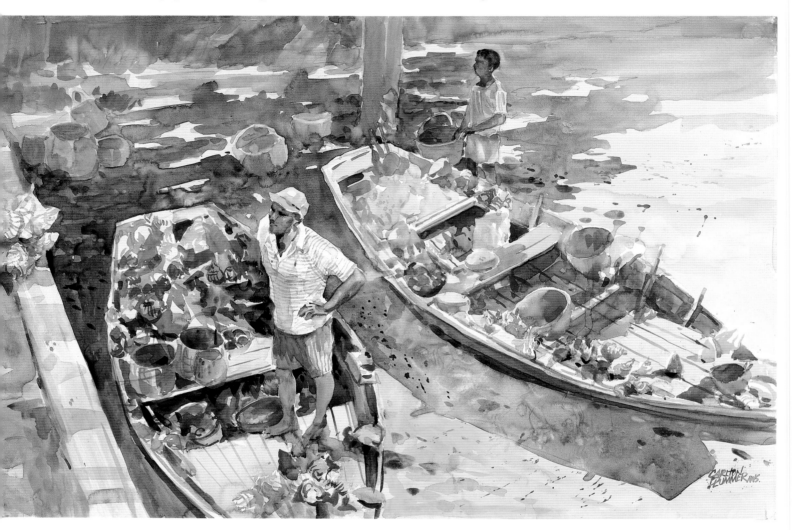

Carlton Plummer *Haitian Light* 20" x 30" Watercolor

 Haitian light represents luminosity. I dramatized the sunlight and shadow by exaggerating the warm tones of the sand with yellows, oranges and pinks, following with blues and violets. Small amounts of warm color were added into the shadow to create textural effects and the impression of bouncing, reflected light.

 The verticals of the figures and tree present a direction opposing to the diagonals of the boats and wall, similar to the situation in *Wintercoast*. In this painting the cast shadow on the sand serves as a cohesive shape that holds the design together.

I like to work on location and paint quickly.

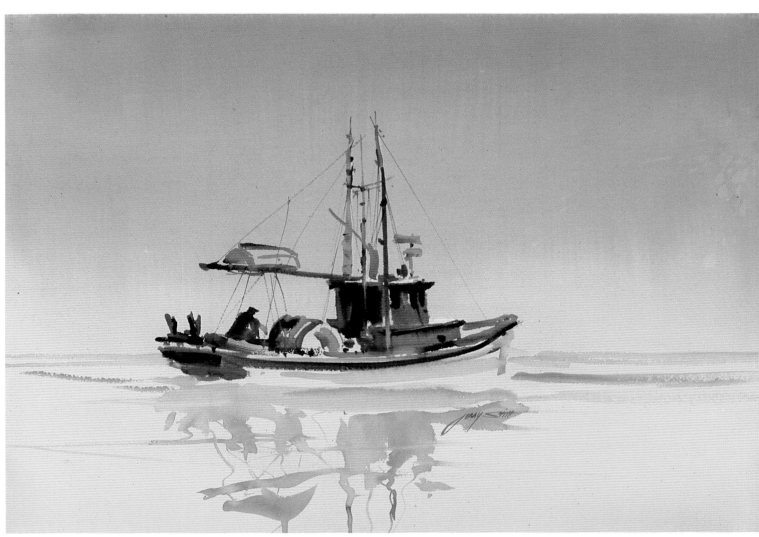

Jerry Stitt *Ballard* 22" x 30" Watercolor

Through the years, I've received much good advice. Two of the most important tips were admonitions from Sergei Bongart, a delightful Russian artist, and one of my favorite instructors.

"Only one bride at wedding," Sergei would say. This is hard to remember when I'm caught up in the wealth of detail surrounding my subject matter. To keep attention on my "bride," to avoid painting too many "bridesmaids," I found that it's a good idea to write down the "bride's" name before I start. I try to keep her name in front of me. It helps me set the mood. In turn, it helps me decide my colors, yet stay focused on my "bride" — that lighthouse, the old fishing boat, the crashing wave.

"First you paint dog, and then you paint fleas," is another of Sergei's bits of wisdom. In other words, add the details to a painting at the completion of the work, in the last minutes. By the time you get down to the details, you will find many are already beautifully suggested. I like to work on location and paint quickly. I start my paintings with gestural abstract under-washes, working with a large brush. I begin with large shapes and I usually paint a full size watercolor in about 45 minutes. Not that time decides a good painting, but working within a time limit helps discipline my approach and avoid needless details and too many fleas.

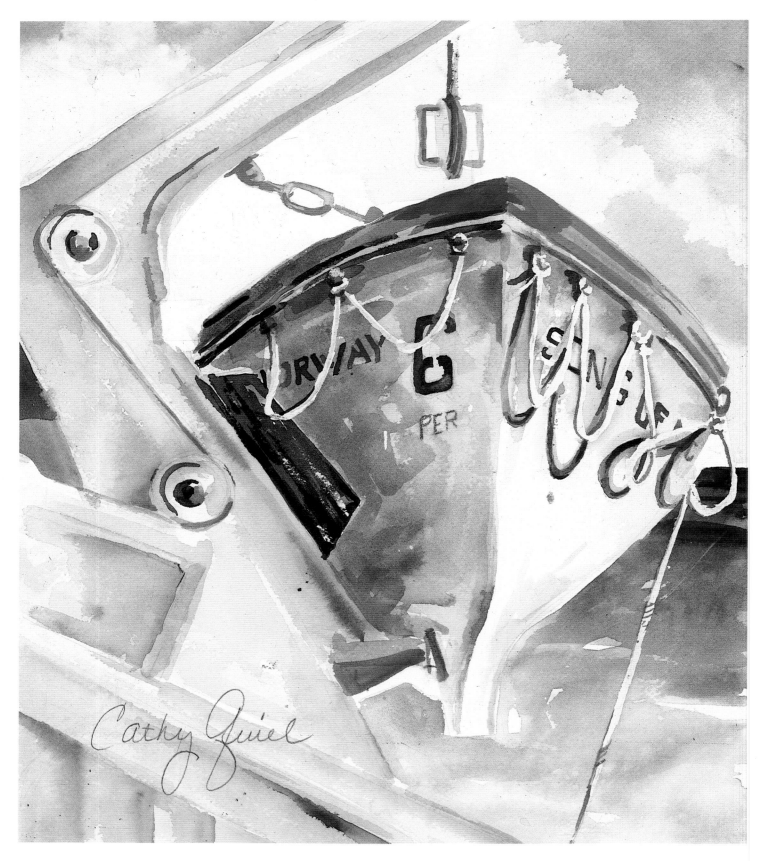

Cathy Quiel *In the Balance* **12" x 13" Watercolor**

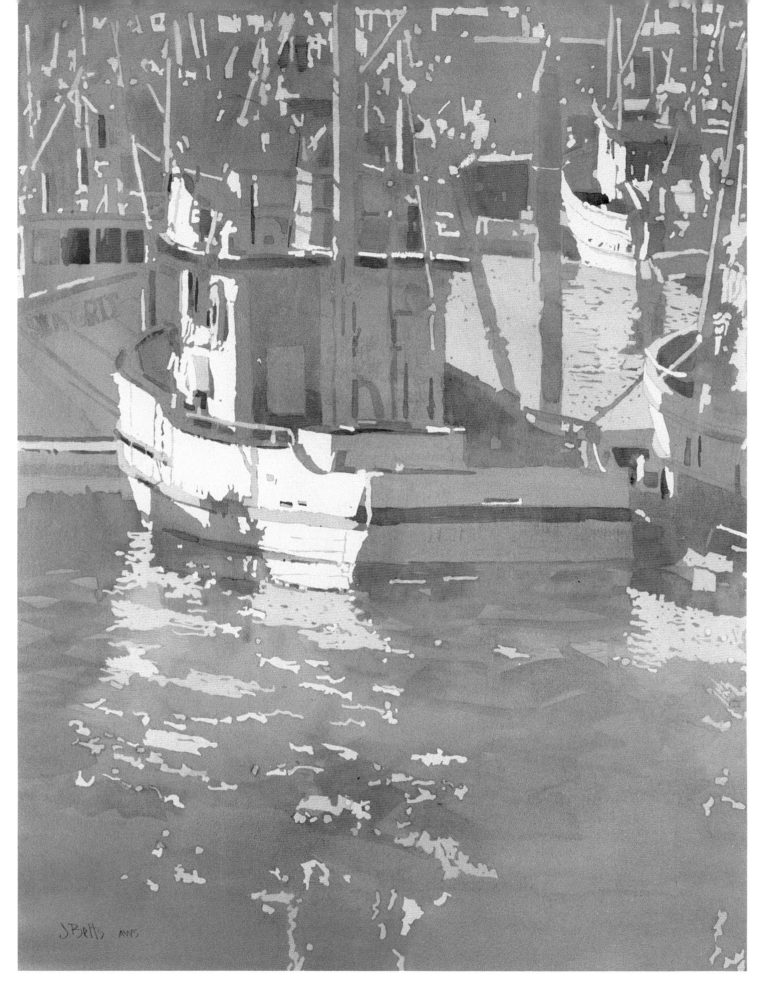

Judi Betts *Sea-Esta* **30" x 22" Watercolor**

Travel

. . . we came upon this charming outdoor cafe . . .

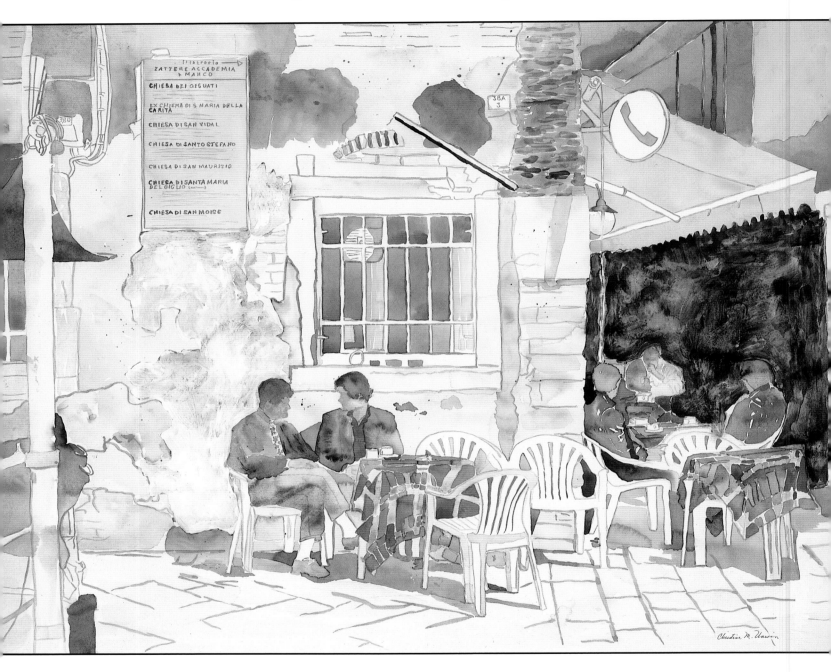

Christine M. Unwin *Cappuccino* 22" x 30" Watercolor and Mixed Media

On one of my recent cruise workshops, we came upon this charming outdoor cafe in Rome. I didn't have time to paint it on the spot, so I took photos and worked on it in my studio. I have tried to capture the relaxed attitude of the patrons enjoying their cappuccino in this outdoor cafe. The wall textures emphasized by the sunlight were very important to me. At one point, I became very frustrated and painted out sections of the painting with gesso. Then I added and subtracted paint. I experience a conflict when working with variations of warm colors such as those in the window because I prefer using cool colors in my palette. I have to make a concerted effort to stick with the warm colors, otherwise, I will find myself unconsciously dipping my brush in to the cool colors.

Judy Morris　　　　*Supper Club*　19" x 28" Watercolor

Giovanni Bonazzon *Rio di Ca' Pesaro* 35" x 50" Watercolor

Rio di Ca' Pesaro is a painting of one of the many canal streets in Venice. The red tones prevail, with accents of warm colors.

I was born in Casale sul Sile, Italy. I chose to live in Venice. It is a most congenial city with a vibrant atmosphere and colors that are liquid and elusive. Venice is inspiring. For me, no other city is as inspiring or has such a sensitive, emotional, romantic essence.

I like the way watercolor lends itself to both soft and strong painting, the bold technique of the fast brush that always leaves some corners unfinished, and some forms barely seen.

Watercolor is a most unreliable medium, probably the most difficult of all. Everything has to be planned. A false move at the last moment can ruin the work. I've made mistakes but I keep working, often dissatisfied with myself, but never bored, always sustained by the desire to persevere.

Giovanni Bonazzon "Sandi" nato a Casale sul Sile il 9.1.1950 si trasferisce sin da giovane a Venezia. Terminati gli studi al Licco Artistico, si iscrive all'Accademia di Belle Arti dove inizia la sua carriera artistica avendo come maestri alcuni fra i più importanti artisti italiani contemporanei. Diplomatosi nel 1974 con il massimo dei voti è professore di disegno e pittura.

Dopo un periodo di sperimentazione tecnica, la sua ricerca artistlca si concentra in particolare sull'acquerello come mezzo espressivo a lui piu con geniale.

E la trasparenza del colore, la luminosità, l'atmosfera, che distingue le opere di "Sandi", il trasformarsi cioé dell'immagine in stato d'animo. La laguna, le dolci vedute del Canal Grande, gli scorci dei piccoli canali, sono il riflesso di una antica tradizione pittorica veneziana e fonte inesauribile di ricerca. Le opere di "Sandi" fanno parte di collezioni pubbliche e private di tutto il mondo.

I noticed a little girl feeding the pigeons.

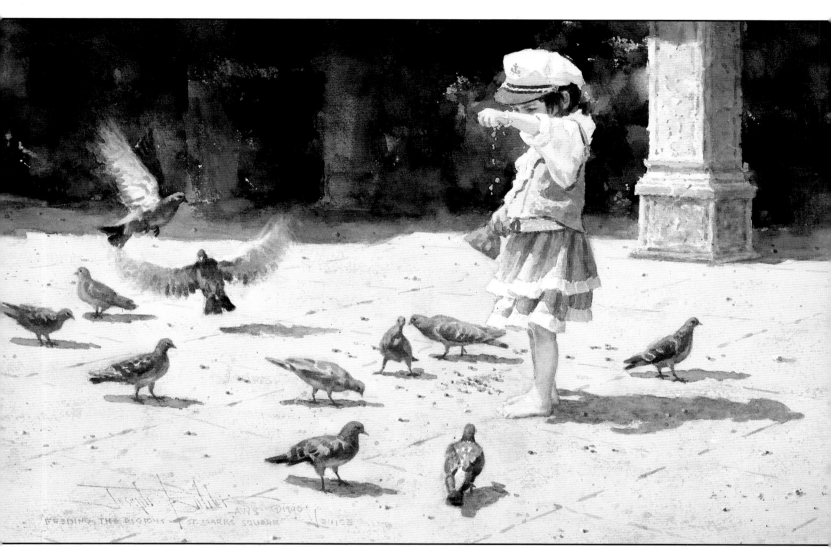

Joseph Bohler *Feeding the Pigeons* 18" x 26" Watercolor

The inspiration for this painting occurred to me on my trip home from Venice. I had been painting inside the large cathedrals and had done some night scenes near the Grand Canal. One day, while walking in the square, I noticed a little girl feeding the pigeons. I took several photos of her before she vanished into the crowd. I did several value sketches and changed the busy background behind the figure to a simple dark shape. Several weeks later, I finished the painting in my studio, using the photos, drawings and some sketches of pigeons.

*It was an awesome sight to see the first balloons light up
in the black sky like giant light bulbs . . .*

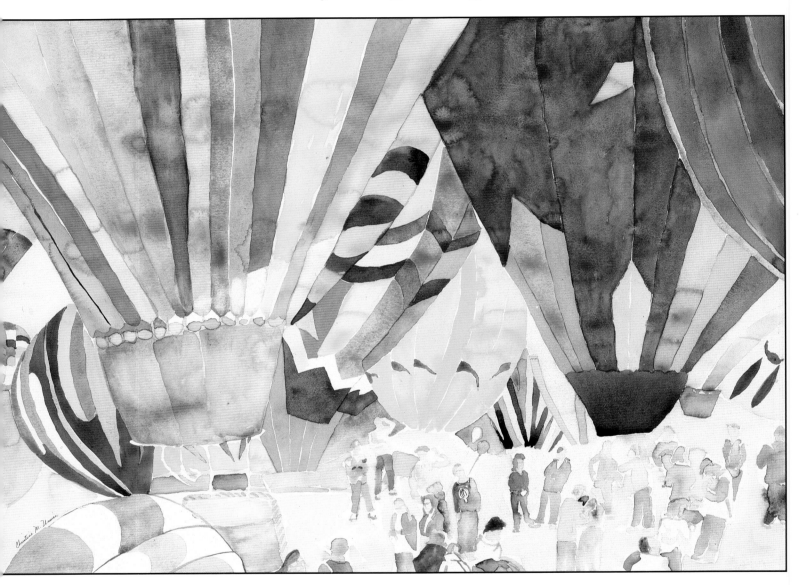

Christine M. Unwin *Balloon Fiesta II* 22" x 30" Watercolor

The Albuquerque Balloon Fiesta was an overwhelming experience. It was an awesome sight to see the first balloons light up in the black sky like giant light bulbs afloat. As the sun rose over the mountains, you could walk among the 650 balloons lying on the field preparing for their mass ascension. As each row was instructed to take flight, the propane burners breathed life into the flat pancake shapes on the ground. Very slowly they became inflated as they filled with hot air, and gradually they stood upright and became ready to ascend. The excited crew jumped on board while the land team held the basket steady. They hung on as long as they could and then released the balloon allowing it to rise majestically into the sky while the watching crowd cheered and applauded.

I used the colors that I felt emotionally. I tried to convey my idea of the mountains, dotted with buildings in a very simple abbreviated way.

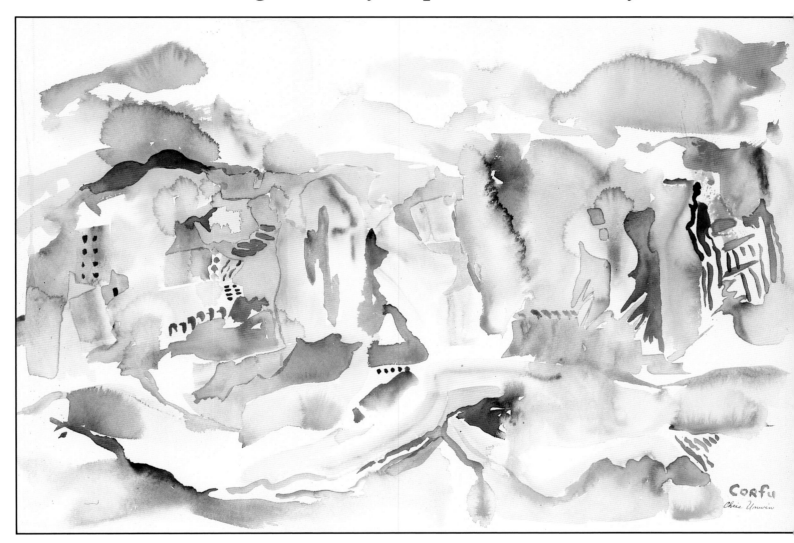

Christine M. Unwin *Corfu* 15" x 22" Watercolor

Did you ever try to paint the color of a scene? The Greek island of Corfu actually looked very green, white and blue. But, I painted it from memory, shortly after touring the island and I used the colors that I felt emotionally. I tried to convey my idea of the mountains, dotted with buildings, in a very simple abbreviated way.

I love the old European cities, filled with so much life and history . . .

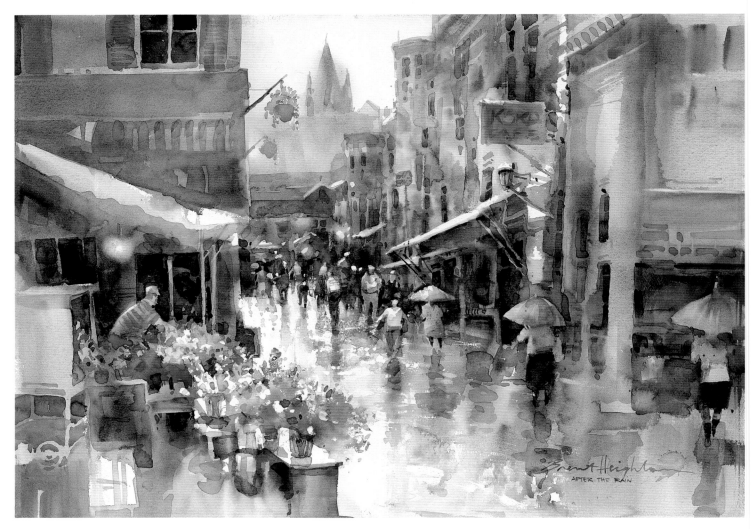

Brent Heighton *After the Rain* 22" x 30" Watercolor

 Early in my career, I had very narrow views about what made a good painting. I was into analyzing every square inch of a museum's painting, often at such a close range that it is surprising I did not leave an imprint of my face right on the art work. Detail and technique seemed to be of ultimate importance. I studied every hair, every blade of grass (you could even tell it was Kentucky Blue Grass), painted with amazing detail. What a master, I'd say to myself. As time went by, the importance of detail and technique diminished. The expressing of my emotions and how I felt inside became important. And that's what painting is all about.

 I was inspired to paint *After the Rain* shortly after a recent trip to Europe. I love the old European cities, filled with so much life and history, the smell of fresh bread in the morning, the street sweepers at work. Everything adds to a feeling of vitality.

I was immediately aware of its wonderful textured walls . . .

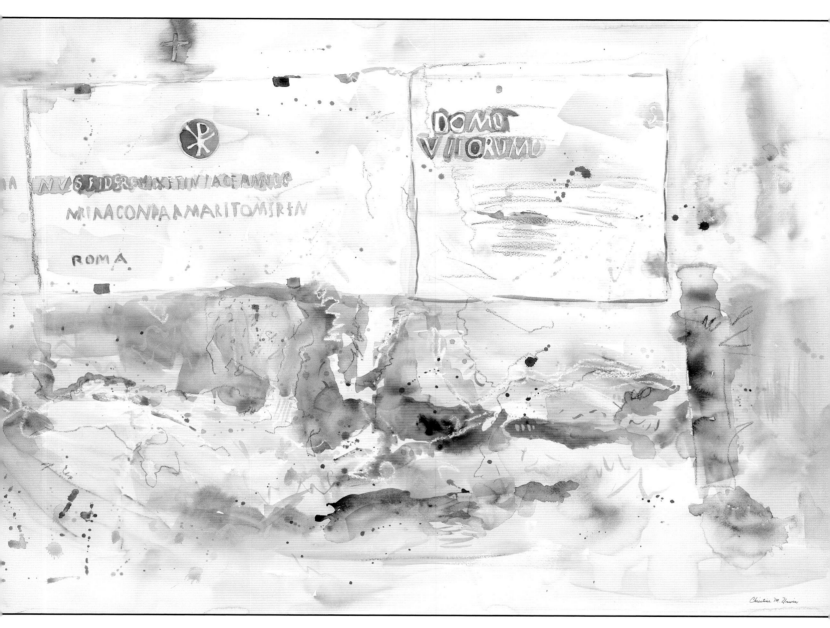

Christine M. Unwin *Roman Wall* 26" x 38" Watercolor

While touring Rome, we visited St. Paul Basilica. I was immediately aware of its wonderful textured walls and knew that I had to paint them. I liked the freedom of building up surfaces, scribbling randomly and allowing a natural rhythm to emerge. Working from a slide, I used crayon, colored pencil and watercolor to create the surface texture.

I . . . enjoy cruises most of all.

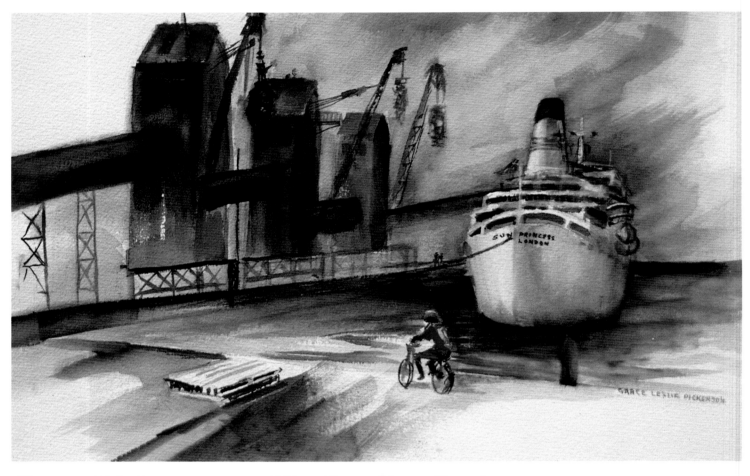

Grace Dickerson　　*The Loading Station*　18" x 24" Watercolor

I always encourage others to try . . . There never is an end to learning about painting!

Grace Dickerson *Elbow Beach* 18" x 24" Watercolor

I'm often asked, "When did you start painting? " Well, I remember drawing a profile of my Dad in his straw hat on the wall of my grandmother's clothes closet. I was about six years old. I used a brown crayon and I was so proud of my work. I thought he would be, too. Instead, I got spanked. "Don't you ever draw on the walls again.", he said. My dear Grandma didn't mind. In fact, she later enrolled me in a Saturday morning children's art class. That was 77 years ago.

Many years later, immediately after graduating from high school, I enrolled as a full time art student at the same school. I studied sculpture, painting and drawing with charcoal and pastel. I especially enjoyed the life class doing portraiture, and later received many commissions. After graduation from our art school, I attended classes at the Chicago School of Art and Cranbrook Academy of Art. My BA degree is from St. Francis College in Fort Wayne and my Master of Fine Arts degree is from the Instituto Allende in Mexico.

When I was nineteen, I traveled to Europe with my landscape teacher, Homer G. Davisson, and his wife. Among others, we visited the picturesque Medieval town of Bruges, Belgium. While there, we painted scenes of its canals, which always remind me of Venice.

I still love to combine travel and painting. I've visited many places throughout the USA, but enjoy cruises most of all. I've been on trips to the Mediterranean, the Caribbean, Bermuda and Alaska. When the ship docks, I paint the picturesque shore scenes that I can see from an upper deck. When I execute a painting, I give much thought to the design and composition.

*The colors are typical of this delightful area. The palm trees
in the background seem to be swaying in the breeze.*

Christine M. Unwin *Marigot, St. Martin* 15" x 22" Watercolor and black ink

This painting was done while on a cruise in the Caribbean. It was sketched on location using a black pen.
Because the afternoon sun was blinding, I went back to the ship and completed it. My leaving the scene helped me
to simplify the painting. It was easier to leave out unnecessary detail and to add just enough calligraphy to set the
mood. The colors are typical of this delightful area. The palm trees in the background seem to be swaying in the
breeze. This painting appeared in the fall issue of American Artist's *Watercolor 90*.

96

People

*When I first saw the nuns of my painting . . .
I was filled with inspiration.*

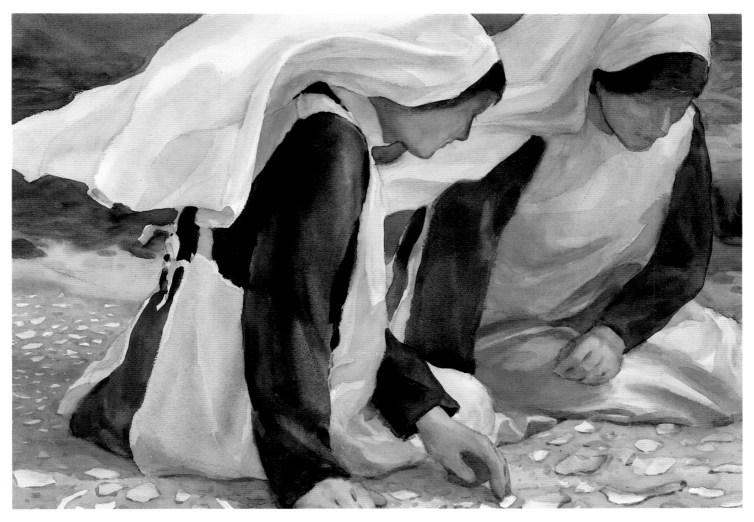

James Soares *Mothers of Pearl* **21" x 29" Watercolor**

Most of all, I paint with love, love for both the subjects of my painting and for the act of painting itself. I try to rely on my Inner Spirit for creativity and guidance in the execution of my painting. I think of my Inner Spirit as the Holy Spirit at work. When I first saw the nuns of *Mothers of Pearl*, I was filled with inspiration. They had just stepped off the bus and were frolicking about and enjoying the beach as young girls might do. I began taking photos and picturing in my mind a series of possible compositions.

An artist should wait for a feeling of love to come from his Inner Spirit. Once that love is experienced, he will never want to paint from his "Ego" self again; his viewers will be moved and they will also feel that love. This is my purpose in painting: To communicate from my Inner Spirit to yours.

When he wanted to get our attention . . ., he would raise his arm and announce: "Nino is Here!"

Christine M. Unwin *Nino is Here* 22" x 30" Watercolor

 I couldn't resist doing a portrait of Nino, our tour guide in Rome. He was impeccably dressed, so typical of the Italians. He was dignified, a man of class and style, almost a work of art in and of himself. When he wanted to get our attention and to direct us to gather round for his comments, he would raise his arm and announce: "Nino is Here!"

*The man had been lying on a street corner in front of
the Washington Monument. I remember thinking he was
the saddest, yet most interesting person I'd ever seen.*

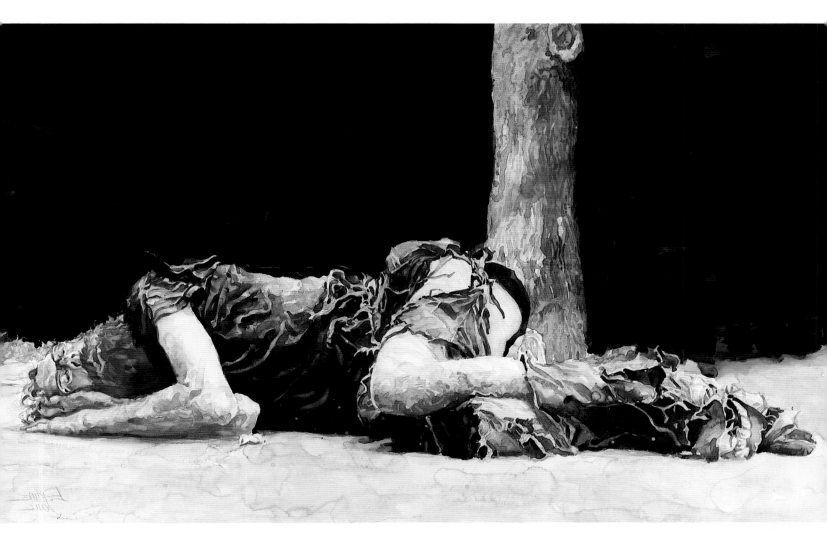

Bill James *Another Day in Paradise* 20" x 34" Watercolor

I always look for interesting people as subjects; someone you wouldn't normally see walking around. Also, I like to create a specific mood to tell a story.

Another day in Paradise was done six years after I saw the subject. The man had been lying on a street corner in front of the Washington Monument. I remember thinking he was the saddest, yet most interesting person I'd ever seen. I did a pastel drawing right away but held off on a watercolor painting until I figured out just the right way to paint him. Most of the time my colors are on the bright side. I had to force myself to work with a limited palette of colors to succeed in creating just the right mood. To make the painting successful, I needed a unique design to convey a feeling of loneliness. It's the most controversial painting I've ever done.

... my basic approach to painting was the same: that form follows content.

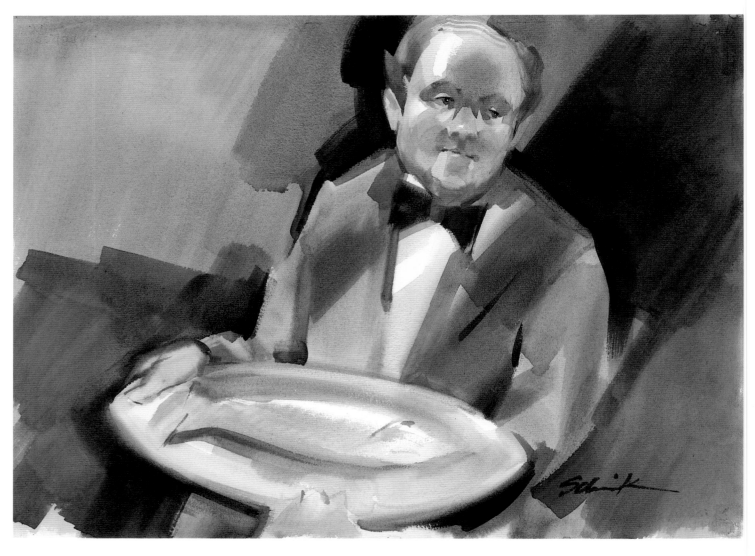

Christopher Schink *The Waiter* 22" X 30" Watercolor

Although the two paintings included here were done a number of years apart and in seemingly different styles, my basic approach to painting was the same: that form follows content. What I want to say in my painting determines the way I say it. What intrigued me about the subject in the earlier painting of the waiter was the expression and gesture of the figure which I tried to capture in a straightforward style. In the later painting of the tap dancer I was more excited about the color and shape possibilities in the subject and worked in a more stylized manner. That painting is simpler with a greater emphasis on design.

Over the years painting has become a more enjoyable process: not just because I've identified what I like but also because I've identified what I don't like — detail, elaboration and texture. I simply leave those things out and proceed to the "good stuff."

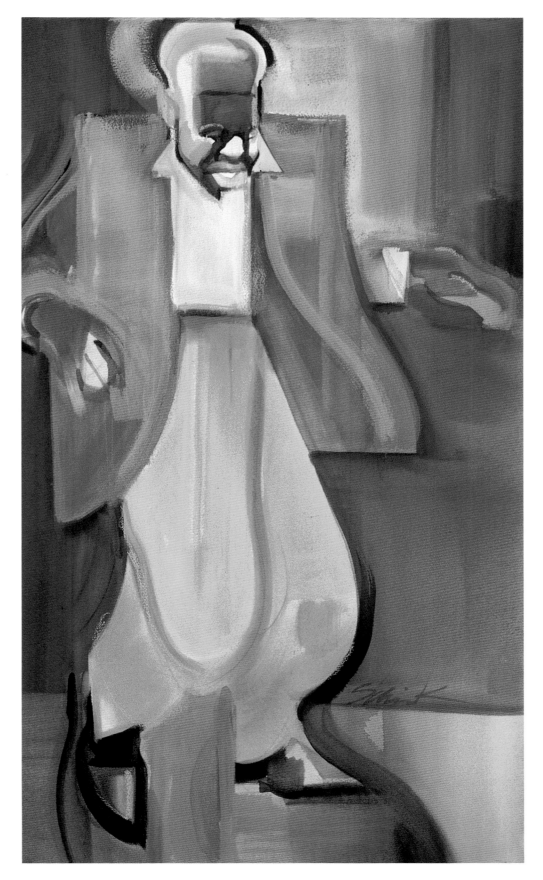

Christopher Schink *The Tap Dancer* 22" X 30" Watercolor

I've always had an interest in figurative work, in painting people. My earliest efforts were sketches and watercolors of the heroes of my youth — football players, cowboys and jazz musicians. I suppose my jazz series is just a continuation of that interest interpreted in a more contemporary way. Musicians make wonderful subjects, striking a variety of active poses and providing a wide range of moods. For me they seem more genuine and authentic than the traditional figure draped languorously over a couch.

*My work lays out a velvet path for me on which
to walk softly and feel the sun on my face.*

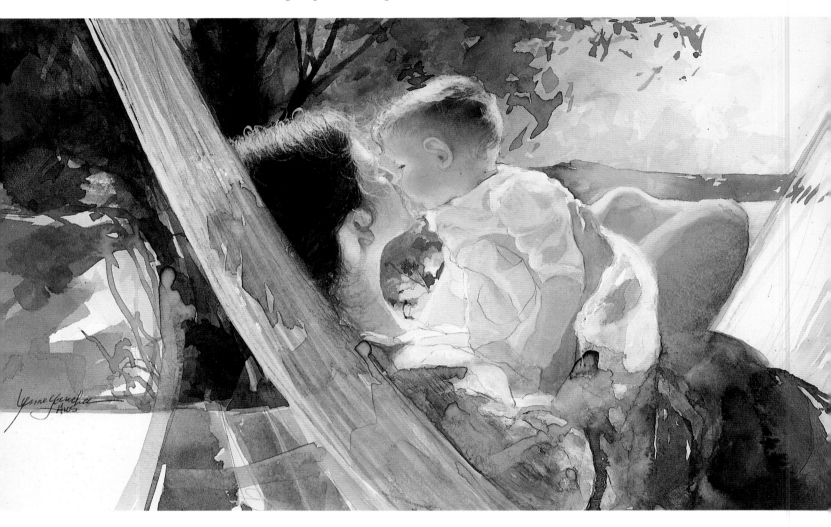

Lynne Yancha *Sweet Breath* 8" X 14" Watercolor

I love my work. It reaches the deepest part of my being. Not only has it been gentle and kind to me; it has soothed my confusion, hurt, and anger, giving me a way to express what is loving and positive in my life. My work lays out a velvet path for me on which to walk softly and feel the sun on my face.

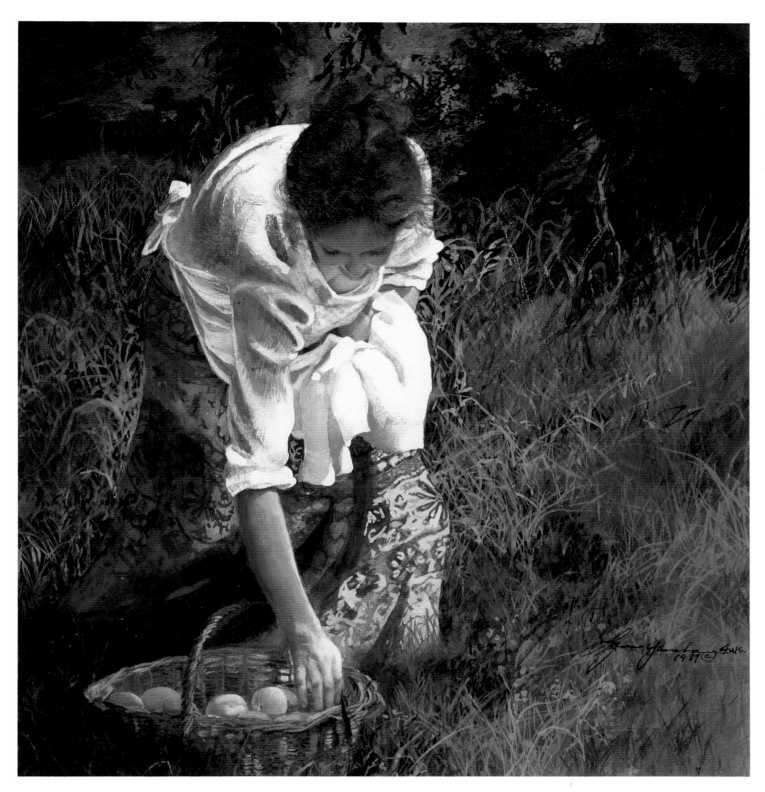

Lynne Yancha *The Gatherer* 14" X 15" Watercolor

The play of strong sunlight heightens contrast which I find stimulating. I painted my friend in an orchard which I pass on my daily morning walk. These walks have become an effective tool to quiet my rumbling mind long enough to see and hear the true harmony of the universe. The subtle changes an orchard goes through during the course of a year always produce a powerful visual experience.

The sunlight created a "super focus" where colors appear richer than life; reflected colors are sharply enhanced; the edges appear crisper and sharper — like a camera focused beyond its capacity.

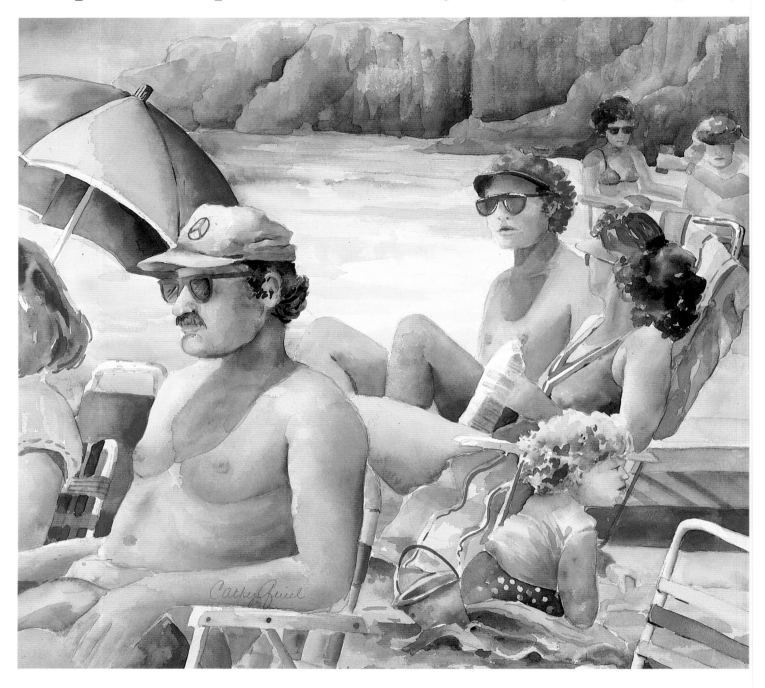

Cathy Quiel *Sun Drenched # 7* **22" x 25" Watercolor**

Exaggerated contrasts produce a "screaming" catalyst that causes me to paint. The eye constantly assimilates sharp value contrasts and color temperatures.

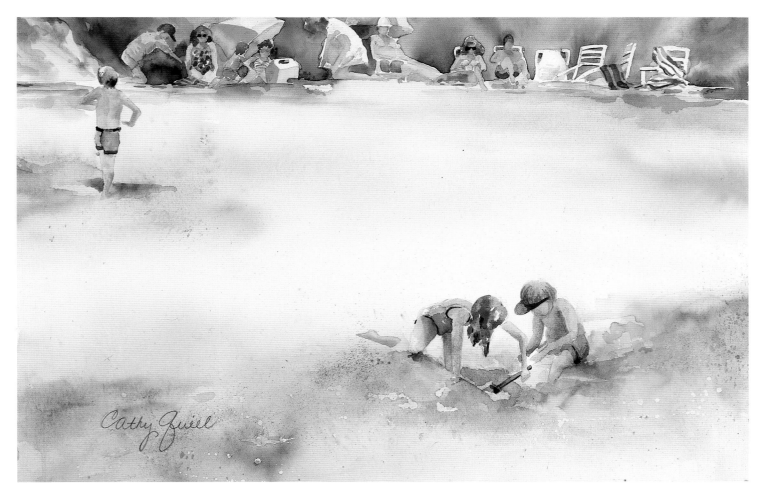

Cathy Quiel *Sun Drenched # 3* 15" x 22" Watercolor

The ideas expressed in my paintings are based on personal concerns and experiences. *Sun Drenched # 3* is a part of a series inspired by a beach camping trip which included 14 adults and 29 children. The sunlight created a "super focus" where colors appear richer than life; reflected colors are sharply enhanced; the edges appear crisper and sharper — like a camera focused beyond its capacity. Exaggerated contrasts produce a "screaming" catalyst that causes me to paint. The eye constantly assimilates sharp value contrasts and color temperatures. I used five rolls of film that weekend. Later, I used the photos as references for my *Sun Drenched* series.

The artist observes reflected colors, notices negative shapes, notes value gradations, and rejoices in the contrasts of shapes and lines. We enjoy an understanding of the world that often is not even noticed by others.

I've always been intrigued by the Past

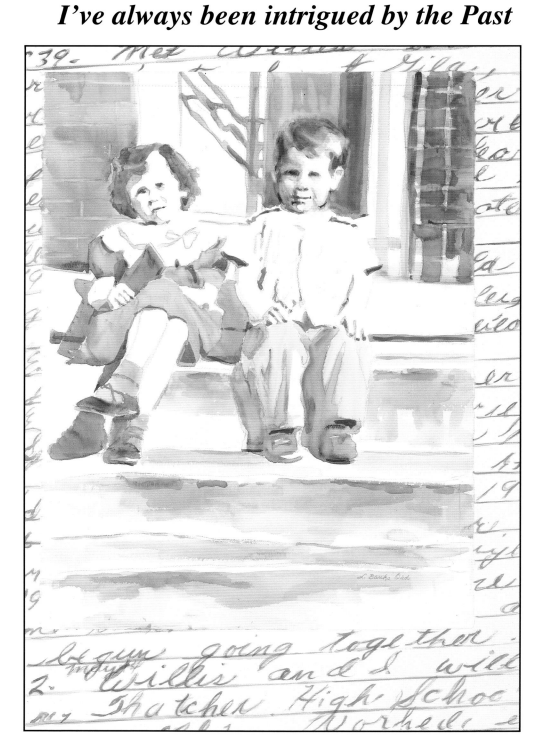

Linda Banks Ord *Confirmation Series # 2* **26" X 37" Watercolor**

I'm very interested in the role that light and shadow play in terms of creating the shape and form of figures.

Linda Banks Ord *Confirmation Series # 3* 26" X 33" Watercolor

I've always been intrigued by the Past, particularly as it influences human behavior in the Present. My recent *Confirmation Series* combines portions of images from my personal past, old family photographs, along with extracts from my mother's journal, kept as a young woman. Both the personal historical images and my mother's journal are printed separately and then sewn together with heavy thread.

I paint on an upright easel because I find it's easier to step back and judge the results. I'm very interested in the role that light and shadow play in terms of creating the shape and form of figures. If the lights and darks have the correct values and are correctly positioned and shaped, a three-dimensional form and space will result. I try to counter this by concurrently using darks and lights to effect an abstract compositional pattern. This will flatten the space again. So there is always a dialogue going on between the flatness and the depth.

I wrote my master's thesis on Color Theory. On occasion, as in *Confirmation Series #3*, the intriguing interaction of color becomes an important sub-plot in the painting.

Bill James

Little Biker 13" x 18" **Watercolor**

I always search for new ways to resolve a particular problem and to create a certain mood within each painting. Originally, I was a pastel artist. Years later, when I decided to try my hand at watercolor, I tried to incorporate the same theories into my watercolors as I had with pastels.

My first watercolors looked good, but they didn't have the same excitement as my pastels. I did some experimenting and discovered that instead of painting with the traditional method of pigment on watercolor paper, I could use a much smoother surface. Instead of sinking into the paper, the pigment would be forced to stay on top of the surface being used. This opened a new realm of possibilities and made my watercolors a lot more exciting.

The artist can inspire the viewer, too!

Jeanne Dobie *Lady Gullah* 19" x 29" Watercolor

The artist can inspire the viewer! While photographers can't alter their subject, the artist can select any part of the subject and transform its usual appearance by infusing the artist's emotions, inspirations, and ideas. Many artists concentrate on accenting the subject — the primary target of the viewer's attention. Instead, I find it exciting to try to subdue the obvious subject and divert the focus to an unexpected element within or surrounding the subject. I transform an overlooked area into the center of attention. This is difficult to achieve with figures because they usually dominate the composition.

Although "Lady Gullah" has a poignant, half-blind countenance, I preferred to accent her gnarled, timeworn hands. I chose a wet-in-wet method to soften and merge the figure into the background. I tried to prevent any element from distracting from the beauty of her hands emerging into the light. I've always pursued "glowing" effects that lead me to develop a pure pigment palette. The palette is described in my book "Making Color Sing." To capture the light that permeates the subject, I mixed pure pigments that, like glass, allow the light to pass through and reflect back from the paper, to treat the viewer to a special effect. And, hopefully, to inspire the viewer, too!

Edee Joppich *The Steven Trilogy* **26" x 40" Watercolor**

　　Steven, my son, is the prototype of many young men of twenty-three. He is ready to take on the world — and win. This compelling idea was the catalyst for this triptych painting. The above painting is the left panel of three views of Steven in similar poses with the same backgrounds. I used many devices, compositional as well as conceptual, to communicate the theme. The intensity of the figure is enhanced by strident, brilliant colors. Steven was a "big man on campus " in college and he is unquestionably "Cool!" The work becomes the connecting object between me and the viewer who may be reminded of a young man in his family or himself as a young man. The moment of pleasure given, validates my effort.

112

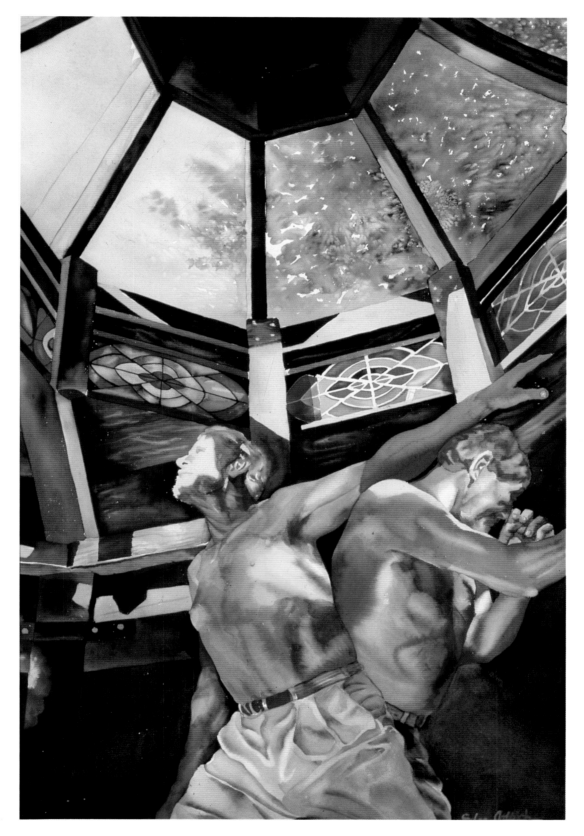

Edee Joppich

The Victor 26" x 40" Watercolor

The Victor depicts the universal human struggle to overcome our weaker nature, freeing the goodness and strength we possess. The imagery of shapes breaking away and soaring upward recurred in my abstract collage paintings of the 70's & 80's. I returned to figurative realism in the 90's because I was looking for a way to again convey this idea. The idea came one chilly morning at a California resort. My husband, Ed, stepping out of a hot tub, was caught in the pure spectrum rays of light reflected from the stained glass in the "rookery" above us. I excitedly grabbed my camera and began directing him in a series of poses that portrayed the valiant human spirit in him, in me, in all of us. Using the photographs for reference, I painted *The Victor* in my studio.

He played from the heart . . . from his very soul.

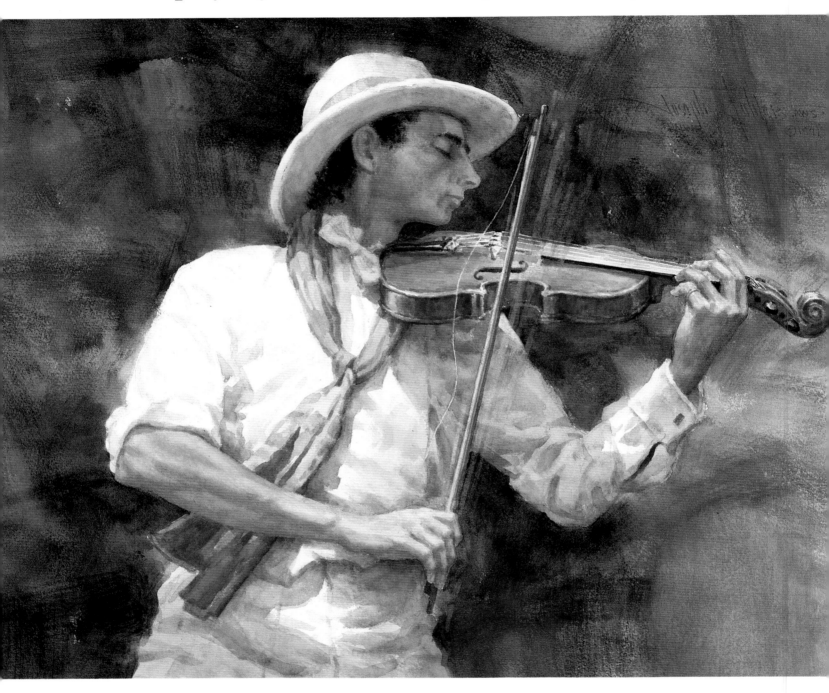

Joseph Bohler *Heart and Soul* 22" x 30" Watercolor

I knew I had to paint this Cornwall street musician when I first saw him. He was in tune with his music as he danced about and played classical folk rhythms. Being a musician myself, I could relate to his deep passion for his music. He played from the heart . . . from his very soul. I painted the figure first, then filled in the background with a brush and sponge.

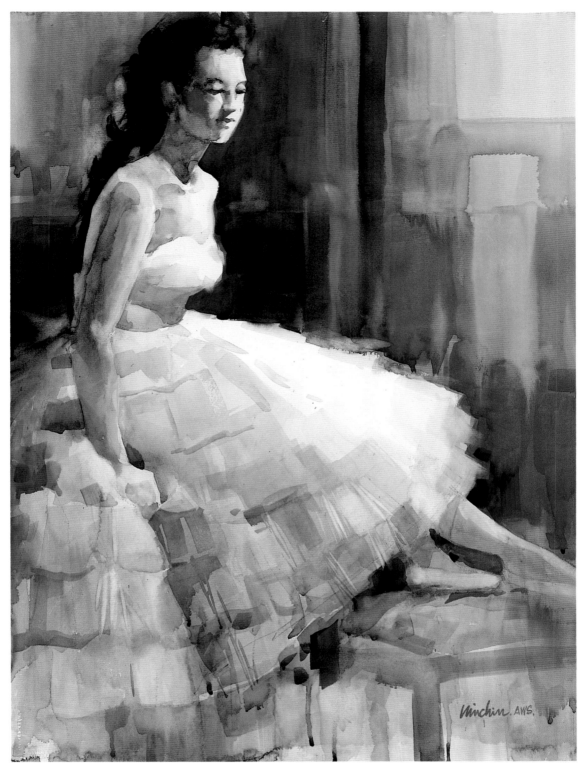

Edward Minchin *The Blue Dress* 21" x 28" Watercolor

I work with a passion that transcends my own limitations. I've found it important to establish more than one approach. Sometimes I develop painter's block. To overcome any mental barriers that would slow my progress and to maintain momentum in my day to day work, I need alternative approaches. I consider as many as five possible ways to deal with my subject matter by working on thumbnail pencil sketches. I take plenty of time choosing the subject and composition that will make a strong design. I like to do full sheet paintings. Working in the 22" x 30" size encourages bold, sweeping, spontaneous brush strokes. The glazes become the under painting that decides the final color and mood of the painting. Keeping my work abstract as long as possible helps me to maintain control at arm's length. Trying to identify objects too quickly can lead to overwhelming attention to detail and loss of focus. I plan slowly for strong design, but paint fast and with passion.

An alternate method is the spontaneous approach, allowing the painting to lead, without a preconceived idea or subject in mind. Even so, I still prepare my thoughts with a positive expectation of success while at the same time trying to overcome my limitations.

I exaggerate light by deepening shadows, thus creating early and evening light. I am especially fond of back lighted subjects . . .

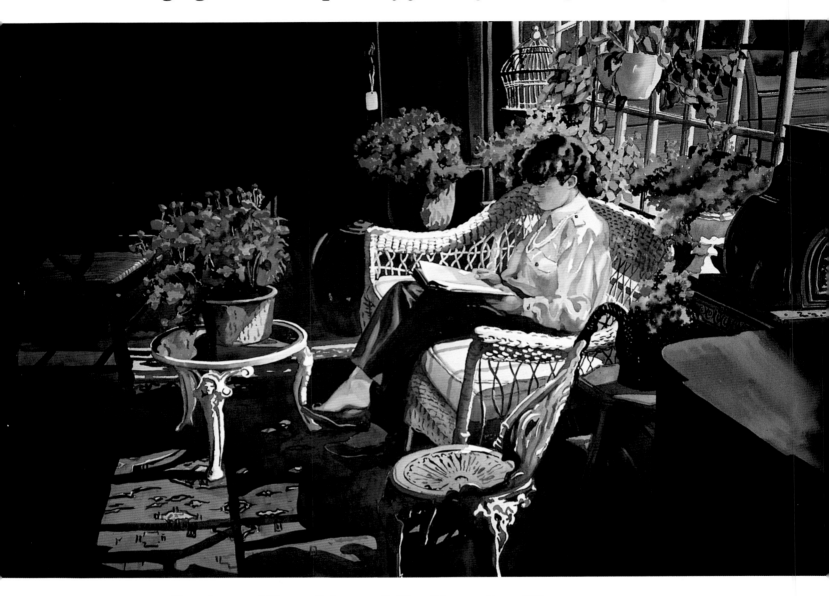

Margaret Graham Kranking *Minding the Shoppe* 22" x 30" Watercolor

To truly depict the essence of a subject, I spend many hours painting directly — either in the field or in a familiar place. While working, I react instinctively to moments of spectacular light — such as the intense light that precedes a breaking storm, or the oblique light of dawn or dusk. These I photograph because such moments are too fleeting to capture on site. Therefore, the work produced in my studio is a blend of the field experience and the light effects captured on film.

Several themes recur in my paintings: urban street scenes, whose special light effects create an ambience to invite the viewer in; domestic arrangements such as potted plants on kitchen window sills; and people, friends and strangers, caught in quiet activity, inviting you to share a moment of their lives.

I exaggerate light by deepening shadows, thus creating early and evening light. I am especially fond of back lighted subjects in which the only clue to the subject's color lies in the rim light highlighted by an outside source.

In every season, as different plants come into bloom, I find inspiration in the play of light upon their fragility, as contrasted against the permanent stylized patterns of the designs of my carpets.

Being an advocate of plein air* painting means I must face the challenge of whatever Nature chooses to throw my way — mist, fog, changing light and passersby. But my real painting excitement comes in the studio when I re-create the special fleeting moments of Nature's spectacular display.

116 *The 19th century French art movement, relating to painting in outdoor daylight.

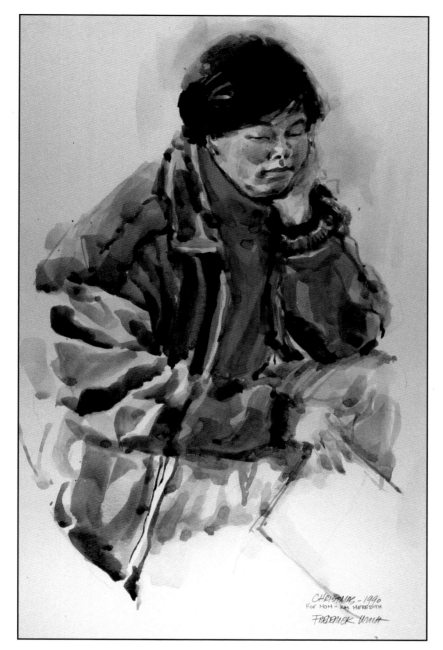

Fred Wong *Kim Meredith* 18" x 22" Watercolor

A good painting can come from anxious desperation — and there's usually an intense anxiety when I confront my annual shopping chores during the Christmas season. It's an established tradition that I don't start shopping until the last minute. Then, I start thinking of what to get for my wife, Yvonne. A few years ago, I waited until Christmas Eve. I greeted that morning in a state of near panic. Kim Meredith, my youngest daughter, was home from college on her holiday break. I found out that she hadn't bought a gift for her mom either! This gave me a great idea! I convinced Meredith to sit for me. I would do her portrait that we both would sign and then present to Yvonne as a joint Christmas gift.

Meredith posed wearing a leather jacket that I had given her the previous Christmas and, for a splash of holiday color, a bright red turtleneck; she rested her head in one supporting hand while holding a magazine in the other. The lights were adjusted to create strong shadow contrasts for both the fabric and leather, and for clearer facial definition. Earlier I had mounted a sheet of Japanese Masa paper, 31" x 21", on museum grade mat board, using water soluble wheat paste. The smooth side was up, giving me a working surface similar to hot pressed paper. The initial roughing-in process was done with light washes of yellow ochre and raw umber. I rarely do any preliminary drawing, opting for direct wash work. The direct approach works better for me. As a greater portion of my emotional response is directed toward the subject matter in the drawing, this leaves the actual painting almost a secondary effort.

I gradually deepened values and tried to heighten color intensities. I worked the painting surface uniformly, much like focusing an image with a camera. The portrait was completed that afternoon, was jointly signed, matted, glazed, framed, wrapped and under the tree on Christmas Eve!

My current watercolor efforts are directed toward figures, landscape and cityscape subject matter. I also am using Western watercolor paper more frequently, rather than using Masa paper exclusively.

Dita, a movie producer, makes magic
through her creative work.

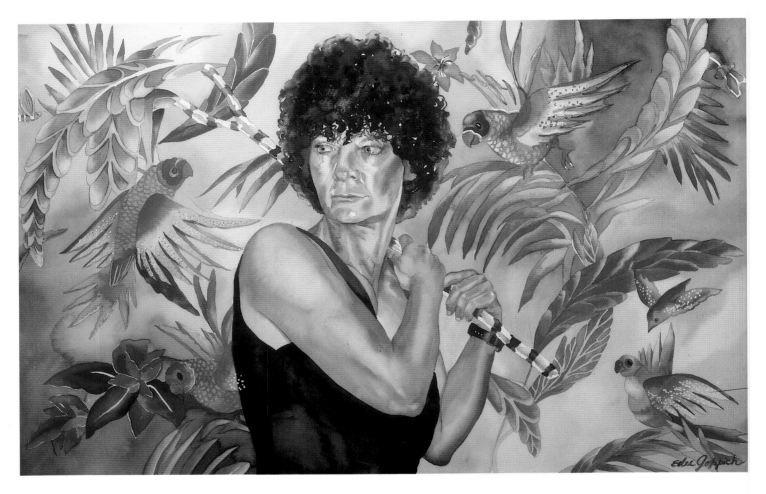

Edee Joppich *Dita Makes Magic* **26" x 40" Watercolor**

She posed for me in Mexico during a brief friendship at a resort. The surrounding birds, drawn from a screened fabric from the islands, symbolize her free and graceful spirit. The stick, a magic stick, is a symbolic image that recurs in legends of the Indians of Michigan's Upper Peninsula. Dita, a movie producer, makes magic through her creative work. Determined, yet vulnerable, she becomes, in this painting, a metaphor for all creative women.

Abstract

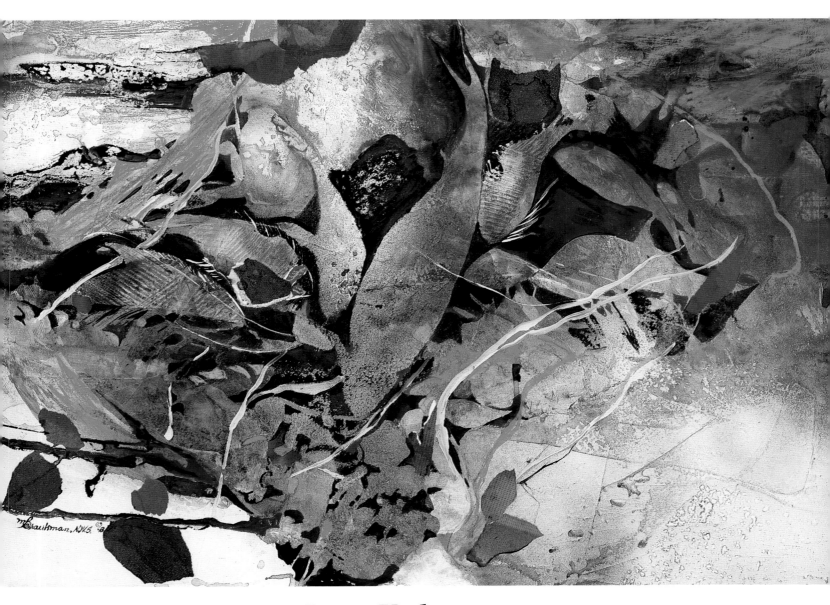

Mary Alice Braukman *Down Under* 22" x 30" Mixed Water-Media & Collage

My professional background is in art education and graphics. My early work involved using the ink tempera resist media. Later, I began to work totally in transparent watercolor. Because I lived a short distance from a college with a strong Graphic's Department, I enrolled in courses to refresh my graphic processing techniques. My work in experimental mixed water media evolved from this background.

It's important to have a basic understanding of the medium before venturing into experimental painting. The artist should understand how staining colors affect opaque colors and what happens when combining acrylics with watercolor, and so forth.

In *Down Under* I tried to achieve a depth by layering water media so that the rich colors in the skeleton beneath would surface. I poured, scraped and lifted out color with various materials and tools. I thought only of design and not of a subject, allowing the painting to mature intuitively. After each layering and lifting of color I would study the painting from all perspectives. The fish began surfacing and then a theme or subject was decided. I worked negatively and positively, bringing them into view.

The very base layers of color are the foundation or skeleton of the piece. This is as important as the finishing procedures. Seeing the subtle variations of color surface is the exciting part.

119

. . . shapes began to suggest ancient faded figures and scrolls, as might be seen on the side of a temple or tomb.

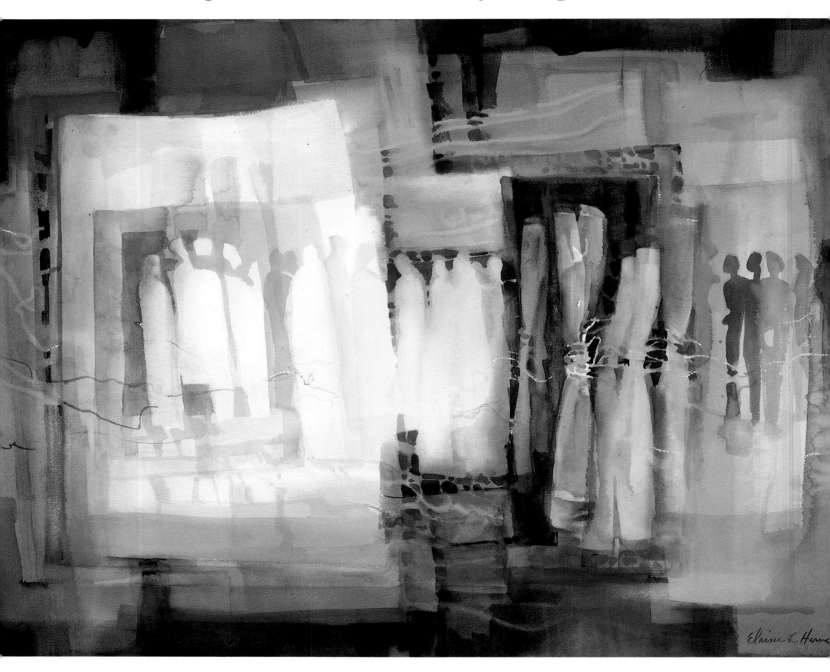

Elaine L. Harvey *Wisdom from Wisdom* 22" x 30" Watercolor

Wisdom from Wisdom is interesting because it was painted using the same techniques I used in an earlier work entitled **Wisdom**. It was created using pieces of mono printed collage. Acrylic paint mixed with a little retarder was applied to a piece of plexiglass. String and some small torn paper shapes and pressed pieces of rice paper were added with a clean brayer. I also printed by hand the "ghost" left in the paint, after the first piece was printed. When the string was turned over, the paint it had picked up created more prints. I then painted a background, using the same colors in watercolor, by breaking the space into a variety of rectangular shapes, and by applying the collage pieces with acrylic gloss medium.

As I worked, the printed and painted shapes began to suggest ancient faded figures and scrolls, as might be seen on the side of a temple or tomb. The idea appealed to me. I began to think of it as having to do with the wisdom passed from generation to generation. I rolled one piece of collage and tied it with real string to make a three-dimensional scroll. Later, I removed the three-dimensional part, but the idea was planted and the subject had become a mysterious, barely discernible group of figures and their wise writings. The idea excited me enough that I decided to reinterpret it using only watercolor. And so was born *Wisdom from Wisdom.*

120

Wondrous splashes of vibrant color burst from the paint.

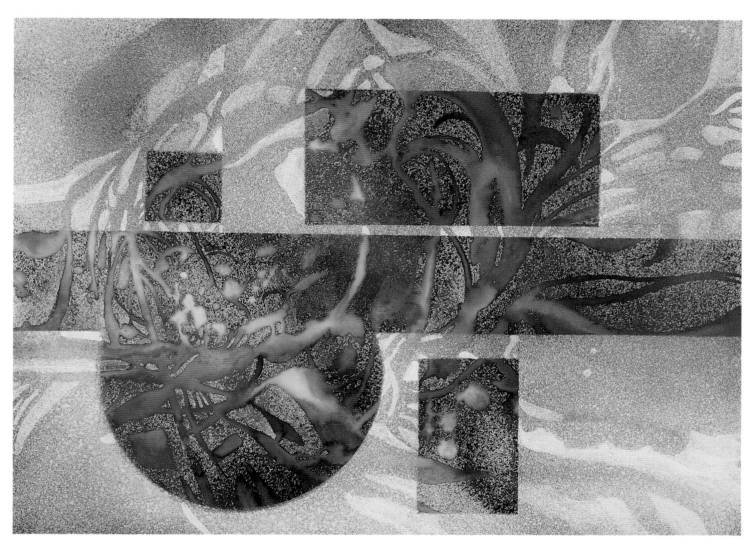

Mary Ann Beckwith *Origins: Spring* 22" x 30" Mixed Media

Years ago, I stood before one of Paul Jenkins' brilliantly colored paintings. Wondrous splashes of vibrant color burst from the paint. I vividly remember the unfettered spirit of his work, the sense of freedom and spontaneity he achieved with the incredible blending of color. I was far too inexperienced to fully appreciate his skillful composition and technical mastery. But the painting not only aroused a feeling of joy, it gave me a fresh, new view of art.

Today, I strive to express the joy, the freedom I experienced when I first viewed Jenkins' work. Bold, free fields of color still inspire me. The excitement of color on a white page lifts me to new heights. I search for the best combination of the elements of color, freedom and composition.

Inks satisfy the color intensity I crave. Using large wet areas, I spray the highly saturated pigments into the water. I begin by creating several areas of bright, free fields of color. Then the painting is left to dry completely. Finally, I focus on the design elements. I layer white ink, watercolor pencil, and washes of watercolor to complete the process and to refine the composition.

Soft colors and organic forms, suggesting spring and emerging growth, influenced ***Origins: Spring***. Once the spontaneous under painting was completed, layers of whites were added using stencils and negative painting. The color was enhanced by using layers of muted watercolor and pencil.

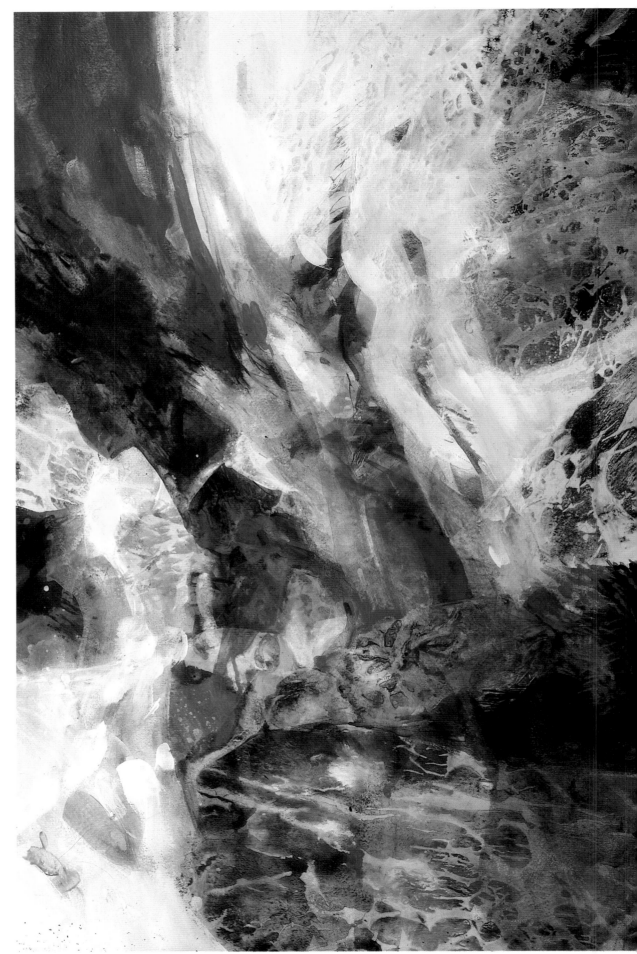

These diptych paintings were begun as a proposal for a much larger work. Diptych was chosen because the format is easily expanded into larger pieces. I tried to abstract my perception of Nature's energy, color and texture. I started with large brushes, using intense color. There was a dialogue between me and the painting. The elements, colors, shapes and textures came together. I studied the work and modified it until I was satisfied. The study took as much time as did the painting. I chose diagonal lines to establish movement. This movement, along with the intense colors and value contrasts created an energetic, dynamic composition.

Marjorie Hogan Chellstorp

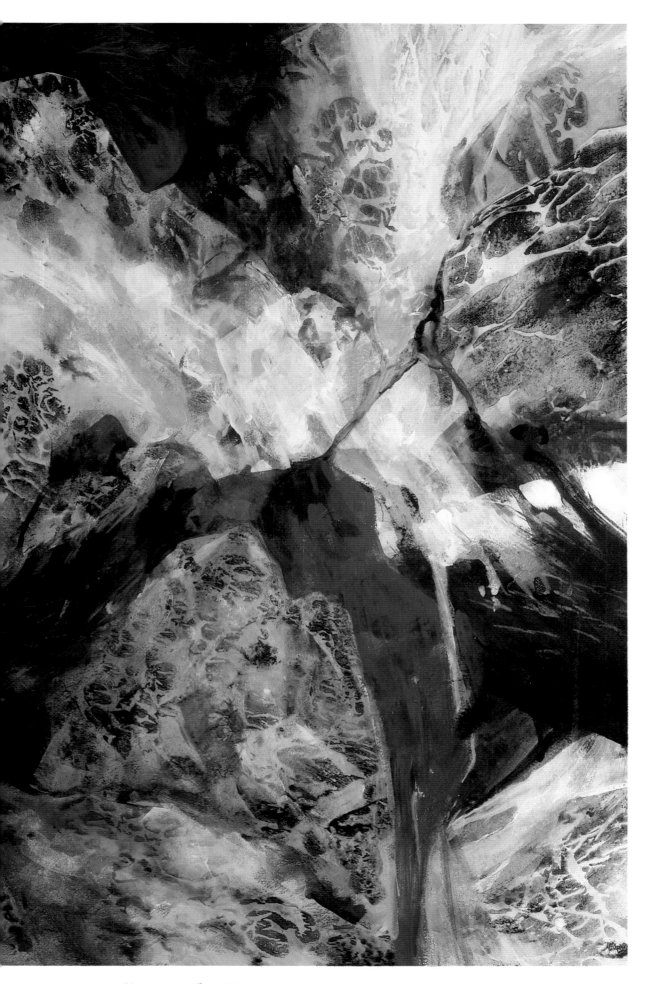

Cascade II 33" x 46" Acrylic on paper

I tried to show the energy of the life cycle, thinking not only of an emerging butterfly, but of all the struggles of life — of how we constantly emerge into our new selves.

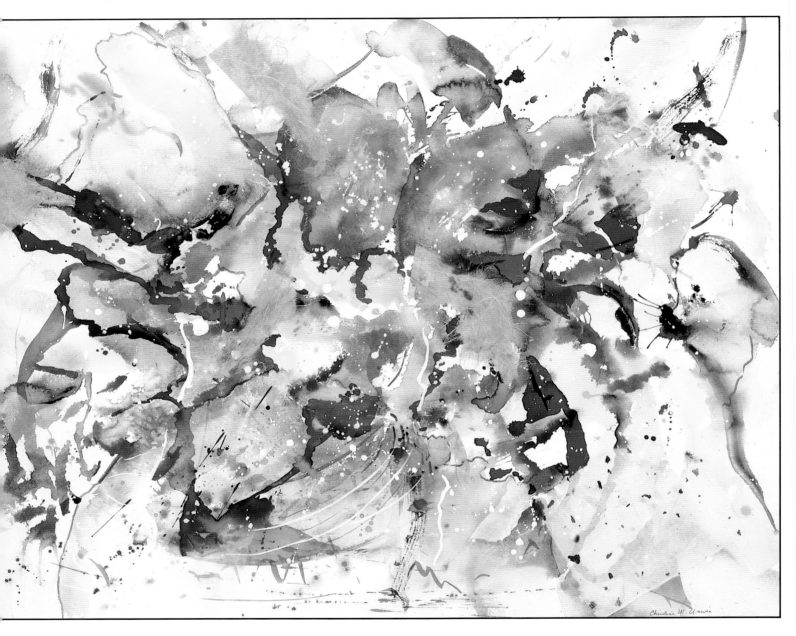

Christine M. Unwin *Metamorphosis* 22" x 27" Collage and Mixed Media

In this painting, I tried to show the energy of the life cycle, thinking not only of an emerging butterfly, but of all the struggles of life — of how we constantly emerge into our new selves. I hope the painting captures the excitement of change that comes with spiritual growth. I used rice paper, watercolor and white ink.

Peggy Zehring *Broken Thought* 22" x 30" Acrylic & Mixed Media

My work comes from the Earth not only philosophically but physically as well. The materials I seek are of the Earth or have been softened and aged by it. I work on handmade paper, enriching the surface with such things as marble dust, sand, ash, joint compound, burlap or whatever else I can find to create interesting textures. The paint I use is acrylic, which I use like watercolor, emphasizing washes that exaggerate the textural surfaces by settling into the lowest relief areas. The color I look for is ancient and or tribal, and the light I seek is softly illuminating, like the Old Truths themselves.

> *... a search for contrast composed of hard and soft edges, bright and dull colors, with variety of both shape and direction.*

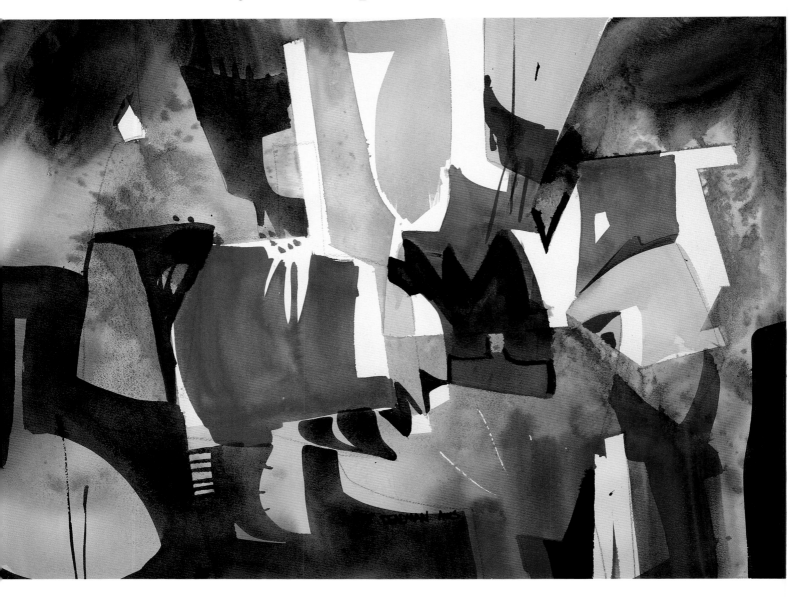

Pat Deadman
Study in Shapes 22" 30" Watercolor

I try to express my impressions of nature and man-made structures, to show my personal reactions and feelings experienced from living, feeling and responding to our world. I don't want to duplicate. I prefer to communicate in other ways.

Study in Shapes is a search for contrast composed of hard and soft edges, bright and dull colors, with variety of both shape and direction.

Different Messages

. . . war toys . . . became symbols of confrontation.
I hoped my sons would never have to go to war.

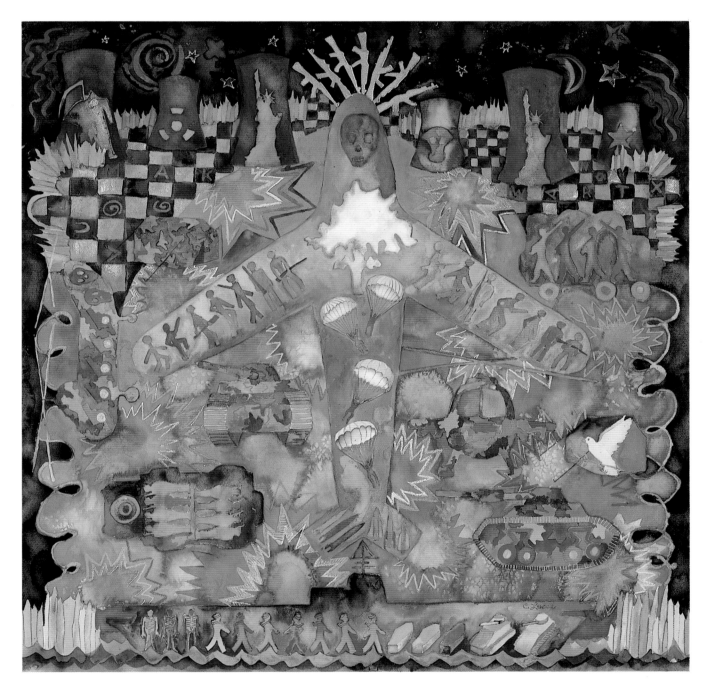

Connie Lucas *Toy Box: Make Luv not War* 39" x 39" Watercolor

This is the second in a series of four paintings. The toy box idea came from the idea that most boxes are square and I enjoy the challenge of working in that format. I've frequently worked with borders as part of my composition. I enjoy the symmetry and repetition. I was influenced by the fact that I have three sons who played with war toys. These toys became symbols of confrontation. I hoped my sons would never have to go to war. The work is about the general unrest and violence in the world, and is a very thoughtful exploration of my inner feelings about the state of interlocking national and worldwide confrontations.

I've taken over 40 workshops and still have much to learn. Leo Smith's teaching has had the greatest impact on my work.

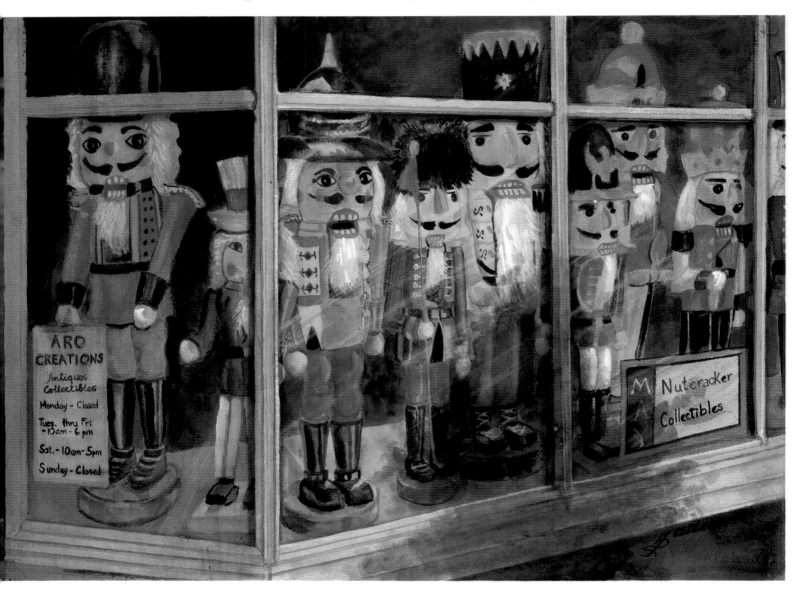

Audrey Ratterman *Nutcracker* 32" x 40" Watercolor

My quest has been to find the purest, most vibrant and permanent watercolor paints available. My palette contains Winsor Newton, Holbein, Rembrandt and my current favorite, Le Franc Bourgeois, pigments. Instead of mixing, I use pure pigment and, if necessary, glazes. All my shadowing is done with the primary or secondary colors, I no longer use greys or browns.

After pigment, I think that design is the most important element in a successful painting. I've taken over 40 workshops and still have much to learn. Leo Smith's teaching has had the greatest impact on my work.

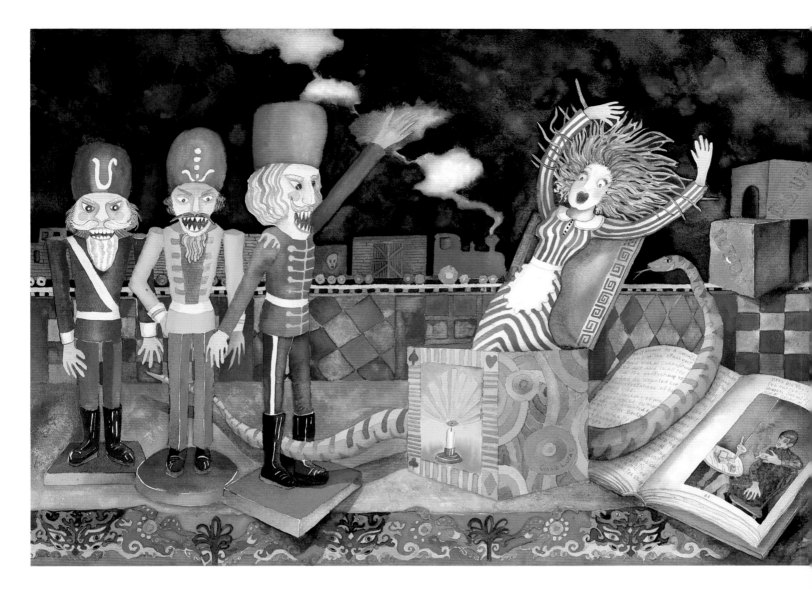

Connie Lucas *The Observer* 28" x 36" Watercolor

I'm interested in polemic art, that is, art about political issues. I have been working on a series about problems in society, violence, war, peace and women's issues. Polemic art is not always popular, but I think I have something to say. Polemic art has a tradition of over four hundred years. William Blake, Honoré Daumier, George Grosz, Otto Dix, Käthe Kollowitz, Ben Shahn and Robert Osborn are artists who have explored this theme.

I'm also interested in how color psychologically affects feelings. Color expresses feelings and emotions. Color pulls you into the piece, catching your attention. Color has strong emotional connotations. Blue is reserved, red is violent and explosive, and green is restful. The German Expressionist believed in the use of intensified color and simplification of form.

At the turn of the century, Paul Fechter saw the Expressionist artist "as an individual who communicates his own feelings, but also one who gives expression to the conflicts and aspirations of their time." Combining color opposites creates feelings of tension and excitement within a work. Gauguin believed, "in the psychological power of color and line and equating pictorial properties with emotional states."

I like to use dynamic composition and the play of line and pattern. I use personal symbols that are easily read by everyone. My interest in objects as symbols has been long standing. I often use shapes of crosses, guns, atomic bursts, statues, bullets, bombs, trucks, jeeps and so forth, to express a variety of ideas. In the past I have used children's toys to convey certain impressions. I hope my viewers will personally identify with the symbols I use, that people will associate my work with their own lives and the world around them.

The Observer addresses the Woman's place in the world. I leave the work open-ended so that the viewer can personally experience the piece. I enjoy art history and include historical paintings that relate to my theme. This work was inspired by the sinister expressions on the faces of some of the nutcracker soldiers.

131

The paintings focus on flight as a symbol for freedom and spirituality, and the desire to transcend earthly boundaries and social constraints.

Kathleen Conover Miller *Contemplation of Flight: Fledgling* 30" x 44" Watercolor

Kathleen Conover Miller *Contemplation of Flight: Renewal* 15" x 22" Watercolor

The *Contemplation of Flight* series originated from my interest in exploring the universality of the desire to fly. Flight is a longed for dream that cuts across cultures, religions, generations, and gender. The paintings focus on flight as a symbol for freedom and spirituality, and the desire to transcend earthly boundaries and social constraints. Various images are used to symbolize flight: feathers, mechanical flying machines, powerful wings, pictographs, Native American bird symbols and motifs from nature.

I've always been intrigued with paintings that have a sense of mystery, paintings which suggest rather than "spell it all out."

Joan Ashley Rothermel *Spirit* 22" x 30" Watercolor

 My work has evolved in a circuitous way, back and forth between abstraction and realism. To the casual eye this may appear indecisive, but actually my painting style is dictated by the subject matter. The search for increased expression is important. To that extent, I think there has been a measured progression.

 Like many artists, when I first took up watercolor, I tried to paint in a realistic way. If I painted an apple, I wanted it to look exactly like an apple! Years later, after becoming comfortable with watercolor, I searched for individuality. I never thought I could paint "out of my head," believing I didn't have enough imagination. Then one day I simply started laying down random washes of color, overlaid with shapes and lines, doodling with the paint. Eventually that process began to suggest recognizable objects, but in a looser and more fluid way of painting than I had previously done. The compositions were not only surprising, they were far more interesting than I could have conceived. Now when I'm painting, it's difficult to tell at what point I'm painting intuitively and at what point I start intellectualizing and considering design principles.

 I've always been intrigued with paintings that have a sense of mystery, paintings which suggest rather than "spell it all out." Airbrush is an ideal tool for achieving misty, vague forms and auras. After a painting is almost finished using a standard brush, I apply air brushed areas for "atmosphere." Then I usually go back in with more brush work, defining shapes which have become obscure.

134

Oriental

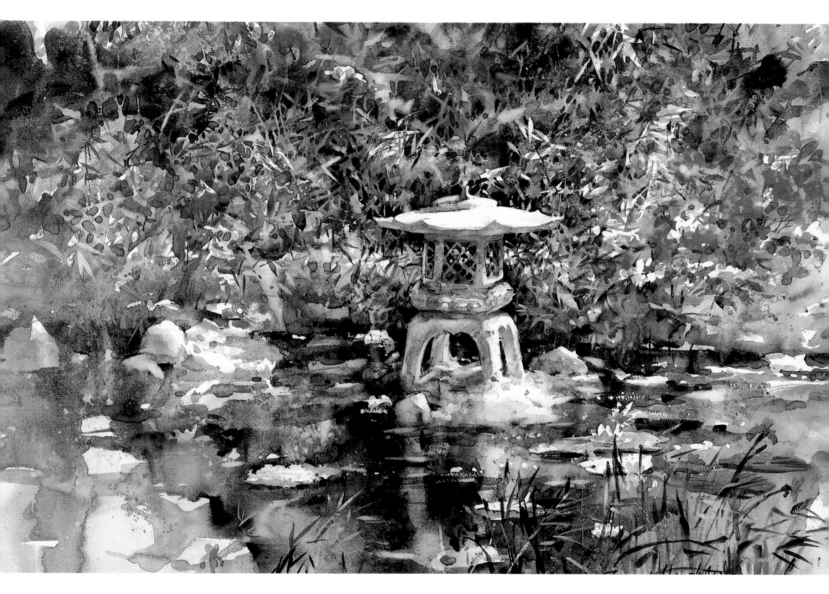

Brent Heighton *Koi Pond* **21" x 29" Watercolor**

 Koi Pond is the result of my love for Japanese landscape. The opulence of color in this painting was so exciting.
The azaleas and rhodos in full bloom in the bright afternoon sun reminded me of fireworks exploding with color.

*Keeping my work abstract as long as possible
helps me to maintain control at arm's length.*

Edward Minchin *Japanese Landscape* 21" x 28" Watercolor

Mark E. Mehaffey *Kanji: Death* 26" x 38" Watercolor

I've been doing a series of paintings based on Japanese calligraphy that includes a style called Kanji. Kanji is an ancient form of picture writing which takes a life time to master. I do not pretend to be an expert. I try to handle the Kanji character as a form or shape in space, giving it depth and meaning beyond the intrinsic meaning of the shape. I try to find single Kanji characters that can be expressed as one shape. The Kanji itself is complex enough without adding more complication to the total composition.

I practice Kanji so that my depiction appears spontaneous and swift. I then paint the character in masking fluid, allowing this to dry and then work the painting from back to front. The Kanji itself is the last thing to be painted.

My ideas were formulated while a Japanese exchange student named Masatomo Goto studied in one of my High School art classes. He and I would practice Kanji together. I was also influenced by the fact that, as a child, I lived for a while in Tokyo. At the time, I even spoke a little Japanese!

. . . the artist seeks the truth within his own awareness of the world around him.

Nancy Fortunato

Last Dance 19" x 21" Watercolor

I believe that before becoming a true artist, you must develop a style of your own. To be truly individual the artist must constantly invent new techniques and employ new forms of expression.

I begin my paintings by soaking a sheet of heavy weight Japanese rice paper in cool water for several days. This removes the sizing. The soaking makes the sheet react like a blotter. I make no outlines on the paper before soaking because the paper will tear wherever pencil lines are drawn. The paper is then placed on a piece of Formica board. Because the paper dries fast, once started there's no time for stopping painting until the piece is finished. I hand-grind my watercolors into a thick consistency. This prevents them from "exploding" too much on the wet paper.

Just as the scientist seeks to learn Nature's laws, the artist seeks the truth within his own awareness of the world around him. This truth is beauty. Paintings resulting from the artist's discovery of something new is truly beautiful. When I finish a painting, I feel very happy, but I also have the feeling that the painting really isn't finished. It's not that the technique isn't complete. It's as though I know the piece can't be finished because Life itself isn't finished.

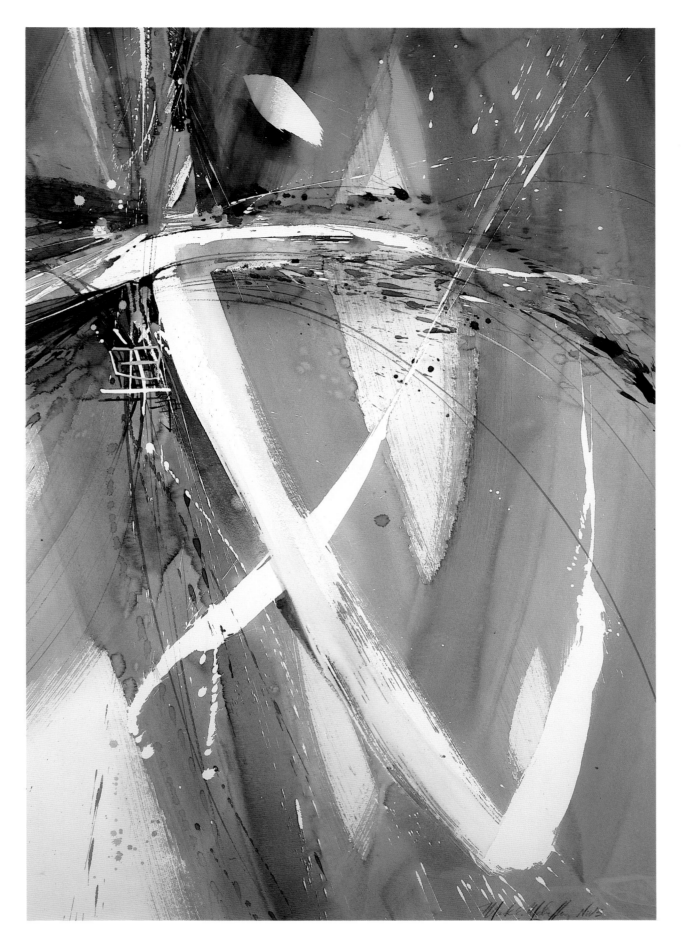

Mark E. Mehaffey *Kanji: War* 27" x 39" Watercolor

Kanji: War is one of the first in my Kanji series. I chose "War" because there has been, and still is, a considerable amount of Japanese-bashing in the media. The Japanese people are not the money hungry scoundrels the media sometimes depicts them to be.

The Artists

Patricia Abraham, 3334 Lowther Way, Sacramento, CA 95842
 p. 29 — *September Song* © Patricia Abraham
 collection of Franci & Brian Nickerson
Mary Ann Beckwith, 619 Lake Ave, Hancock, MI 49930
 p. 121 — *Origins: Spring* © Mary Ann Beckwith
 collection of the artist
Igor Beginin, 43524 Bannockburn Dr, Canton, MI 48187
 p. 125 — *Rites of Spring* © Igor Beginin
 collection of Dr. and Mrs. Jaejong Kim, Clarkston, MI
Judi Betts, AWS, P.O. Box 3676, Baton Rouge, LA 70821-3676
 p. 68 — *Sunshine Serenade* © Judi Betts
 collection of Zainab Al-Sayyad
 p. 69 — *On the Sunny Side of the Street* © Judi Betts
 collection of the artist
 p. 84 — *Pier Pressure* © Judi Betts
 collection of Dr. and Mrs. Marvin Rothenberg
 p. 85 — *Sea-Esta* © Judi Betts
 collection of Mr. and Mrs. C. Robert Potter
Virginia Blackstock, 3101 L Road, Hotchkiss, CO 81419
 p. 46 — *Puye Cliff Dwelling II* © Virginia Blackstock
 collection of the artist
 p. 47 — *Copper & Brass II* © Virginia Blackstock
 collection of the artist
Joseph Bohler, AWS, P.O. Box 387, Monument, CO 80132
 p. 48 — *Grand Canyon* © Joseph Bohler
 collection of — private collection
 p. 89 — *Feeding the Pigeons* © Joseph Bohler
 collection of the artist
 p. 114 — *Heart and Soul* © Joseph Bohler
 collection of the artist
Giovanni Bonazzon, Viale Trento Trieste,
 51, 31030 Casale sul Sile (TV) Italy
 p. 88 — *Rio di Ca' Pesaro* © Giovanni Bonazzon
 collection of the artist
William Borden, 2617 Raymond, Dearborn, MI 48124
 p. 60 — *Day Dream Machine* © William Borden
 collection of the artist
 p. 61 — *Kern's Truck* © William Borden
 collection of the artist
Marilynn Branham, PO Box 86, Ingram, TX 78025
 p. 40 — *Fall Festival* © Marilynn Branham
 collection of the artist
Mary Alice Braukman, NWS, 636 19th Ave NE,
 St Petersburg, FL 33704
 p. 119 — *Down Under* © Mary Alice Braukman
 collection of the artist
Charlotte Britton, AWS, 2300 Alva Ave, El Cerrito, CA 94530
 p. 20 — *Potting Shed* © Charlotte Britton
 collection of Mr. & Mrs. Thomas Still
Al Brouillette, AWS, 1300 Sunset Court, Arlington, TX 76013
 p. 66 — *Dimensions VIII* © Al Brouillette
 collection of the artist
Marjorie Hogan Chellstorp, 29923 Ravenscroft,
 Farmington Hills, MI 48331
 p. 122 & 123 — *Cascade II* © Marjorie Hogan Chellstorp
 collection of the artist

Johnnie Crosby, 17460 Cedar Lake Circle, Northville, MI 48167
 p. 13 — Final Touch © Johnnie Crosby
 collection of the Artist
Pat Deadman, AWS, NWS, 105 Townhouse Lane,
 Corpus Christi, TX 78412
 p. 128 — *Study in Shapes* © Pat Deadman
 collection of the artist
Grace Dickerson, 13326 Hardesty Rd., Fort Wayne, IN 46845
 p. 94 — *Loading Station* © Grace Dickerson
 collection of the artist
 p. 95 — *Elbow Beach* © Grace Dickerson
 collection of the artist
Jeanne Dobie, AWS, NWS, Hidden Valley Studio
 160 Hunt Valley Circle, Berwyn, PA 19312
 p. 111 — *Lady Gullah* © Jeanne Dobie
 collection of the artist
Lily Dudgeon, 23450 Lawrence, Dearborn, MI 48128
 p. 49 *Yellowstone* © Lily Dudgeon
 collection of the artist
Nita Engle, 177 County Rd. 550, Marquette, MI 49855
 p. 6 — *Ireland and the Sea* © Nita Engle
 collection of John Armstrong
 p. 38 — *Beachy Head* © Nita Engle
 collection of Nita Engle
 p. 36 & 37 — *Rocks & Sea* © Nita Engle
 collection of Don and Chris Unwin
 p. 45 — *Bell Song* © Nita Engle
 collection of the artist
Janet Fish, 101 Prince St, New York, NY 10012
 p. 73 — *Sentinels* © Janet Fish
 collection of the artist
 p. 75 — *Teapot & Fig Newtons* © Janet Fish
 collection of the artist
 p. 15 — *Goldfish & Dark Vase* © Janet Fish
 collection of the artist
Nancy Fortunato, 249 North Marion Street, Palatine, IL 60067
 p. 138 — *Last Dance* © Nancy Fortunato
 Courtesy of the Leigh Yawkey Woodson
 Art Museum, Wausau, WI
Marc Getter, 160 West 71 Street #14 D, New York, NY 10023
 p. 32 — *Woodstock Stream* © Marc Getter
 collection of artist
 p. 72 — *House Doorway* © Marc Getter
 collection of the artist
Jean Grastorf, AWS, NWS, 6049 4th Ave. North
 St. Petersburg, FL 33710
 p. 110 — *Transfer at Williams Park*
 © Jean Grastorf
 collection of The Neville Public Museum
 of Brown County, Green Bay WI
Irwin Greenberg, AWS, 17 W. 67 St., New York, NY 10023
 p. 65 — *The Blue Fence* © Irwin Greenberg
 collection of the artist
Linda Gunn, 5209 Hanbury Street, Long Beach, CA 90808
 p. 59 — *Family Unity* © Linda Gunn
 collection of the artist

Elaine L. Harvey, 1620 Sunburst Dr., El Cajon, CA 92021
 p. 120 — *Wisdom from Wisdom*
 © Elaine L. Harvey
 collection of the artist

Marsha Heatwole, Route 2, Box 123, Lexington, VA 24450
 p. 52 — *Punda Milia Kuja Na Kwenda*
 © Marsha Heatwole
 collection of the artist
 p. 53 — *Twigas* © Marsha Heatwole
 collection of the artist

Brent Heighton, 13331 55A Ave, Surrey, BC Canada V3X 3B5
 p. 27 — *Loons in the Mist* © Brent Heighton
 collection of the artist
 p. 92 — *After the Rain* © Brent Heighton
 collection of the artist
 p. 135 — *Koi Pond* © Brent Heighton
 collection of the artist

Mary Hickey, 2204 N. Elizabeth, Dearborn, MI 48128
 p. 54 — *Cats, O Glorious Cats* © Mary Hickey
 collection of the artist
 p. 55 — *Whiskers Marie Helga Hickey*
 © Mary Hickey
 collection of the artist
 p. 56 — *Victorian Cat* © Mary Hickey
 collection of the artist

Bill James, AWS, PSA, 15840 SW 79th Ct., Miami, FL 33157
 p. 108 — *Little Biker* © Bill James
 collection of the artist
 p. 99 — *Another Day in Paradise*
 © Bill James
 collection of the artist

Edee Joppich, 24547 Creekside Drive, Farmington Hills, MI 48018
 p. 112 — *The Steven Trilogy* © Edee Joppich
 collection of the artist
 p. 113 — *The Victor* © Edee Joppich
 collection of the artist
 p. 118 — *Dita Makes Magic* © Edee Joppich
 collection of the artist

Danguole Jurgutis, 32484 Chesterbrook,
 Farmington Hills, MI 48018
 p. 41 — *Starry Night* © Danguole Jurgutis
 collection of the artist

Margaret Graham Kranking,
 3504 Taylor Street, Chevy Chase, MD 20815
 p. 19 — *Sunlit Violets & Cyclamen*
 © Margaret Graham Kranking
 collection of Dr. & Mrs. Henry S. Blank
 p. 70 — *Autumn Morning, Georgetown*
 © Margaret Graham Kranking
 collection of Mr. & Mrs. Paul E. Jamison
 p. 116 — *Minding the Shoppe*
 © Margaret Kranking
 collection of Citizens National Bank,
 Evansville, IN

Jan Kunz, P.O. Box 868, Newport, OR 97365
 p. 109 — *Cheri* © Jan Kunz
 collection of Mr. & Mrs. Dennis Brock

Lillian Langerman, 15985 Harden Circle, Southfield, MI 48075
 p. 14 — *Dance of the Tiger Lilies*
 © Lillian Langerman
 collection of the artist

Maggie Linn, AWS, 921 N. Front St., Marquette, MI 49855
 p. 24 & 25 — *Hazy Afternoon*
 © Maggie Linn
 collection of the artist

Connie Lucas, 1933 Bellingham, Canton, MI 48188
 p. 131 — *The Observer* © Connie Lucas
 collection of the artist
 p. 129 — *Toy Box: Make Luv not War*
 © Connie Lucas
 collection of the artist

Lena Massara, 36720 Almond Circle, Farmington Hills, MI 48335
 p. 33 — *Really Spring* © Lena Massara
 collection of the artist

Lorraine Chambers McCarty, 1112 Pinehurst,
 Royal Oak, MI 48073
 p. 58 — *Guitar with Bear*
 © Lorraine Chambers McCarty
 collection of the artist
 p. 62 & 63— *Departure*
 © Lorraine Chambers McCarty
 collection of David and Luz Gleicher

Joan McKasson, 7976 Lake Cayuga Dr., San Diego, CA 92119
 p. 16 — *Garden Bouquet* © Joan McKasson
 Courtesy of Aguajito del Sol Gallery

Susan McKinnon , 2225 SW Winchester Ave., Portland, OR 97225
 p. 18 — *Spring Blush* © Susan McKinnon
 collection of — private collection
 p. 79 — *Portside V* © Susan McKinnon
 collection of the artist
 p. 83 — *Nestled in Naoussa*
 © Susan McKinnon
 collection of the artist

Mark Mehaffey, 5440 North Zimmer Road,
 Williamston, MI 48895
 p. 137 — *Kanji: Death* © Mark Mehaffey
 collection of — private collection
 p. 139 — *Kanji: War* © Mark Mehaffey
 collection of — private collection

Joe Miller, 300 A Industrial Park Road, Boone, NC 28607
 p. 30 — *Nobody Ever Left Aunt Hazel's*
 House Hungry © Joe Miller
 collection of the artist
 p. 31 — *Blue Ridge Mountains* © Joe Miller
 collection of the artist

Kathleen Conover Miller, 1390 Vandenboom,
 Marquette, MI 49855
 p. 132 — *Contemplation of Flight: Fledgling*
 © Kathleen Conover Miller
 collection of the artist
 p. 133 — *Contemplation of Flight: Renewal*
 © Kathleen Conover Miller
 collection of the artist

Edward Minchin, AWS, P.O. Box 160, Rockland, MA 02370
 p. 21 — *Sunflower Explosion II*
 © Edward Minchin
 collection of the artist
 p. 78 — *Tomato Time* © Edward Minchin
 collection of the artist
 p. 115 — *The Blue Dress*
 © Edward Minchin
 collection of the artist
 p. 136 — *Japanese Landscape*
 © Edward Minchin
 collection of the artist

Judy Morris, 2404 East Main Street, Medford, OR 97504
 p. 76 — *Clean Sweep* © Judy Morris
 Courtesy of E.S. Lawrence Gallery,
 Aspen, CO
 p. 87 — *Supper Club* © Judy Morris
 Courtesy of Maueety Galllery at Salishan,
 Gleneden Beach, Oregon
Linda Banks Ord, 11 Emerald Glen, Laguna Niguel, CA 92677
 p. 106 — *Confirmation Series # 2*
 © Linda Banks Ord
 collection of Alan and Sharon Banks
 p. 107 — *Confirmation Series # 3*
 © Linda Banks Ord
 collection of Willis and Phyllis Banks
Carlton Plummer, AWS, 10 Monument Hill Road,
 Chelmsford, MA 01824
 p. 34 — *Wintercoast* © Carlton Plummer
 collection of the artist
 p. 80 — *Haitian Light* © Carlton Plummer
 collection of the artist
Cathy Quiel, 494 Stanford Place, Santa Barbara, CA 93111
 p. 82 — *In the Balance* © Cathy Quiel
 collection of the artist
 p. 104 — *Sun Drenched # 7* © Cathy Quiel
 collection of the artist
 p. 105 — *Sun Drenched # 3* © Cathy Quiel
 collection of the artist
Audrey Ratterman, 6763 Yarborough
 Shelby Township, MI 48316
 p. 130 — *Nutcracker* © Audrey Ratterman
 collection of the artist
Joan Rothermel, 221 46th Street, Sandusky, OH 44870
 p. 134 — *Spirit* © Joan Rothermel
 collection of the artist
Christopher Schink, 3811 Farm Hill Blvd.,
 Redwood City, CA 94061
 p. 100 — *The Waiter* © Christopher Schink
 collection of Don and Chris Unwin
 p. 101 — *The Tap Dancer* © Christopher Schink
 collection of the artist
James Soares, NWS, 1006 E. Lincoln, Reedley, CA 93654
 p. 97 — *Mothers of Pearl* © James Soares
 collection of the artist
Jerry Stitt, 1001 Bridgeway #225, Sausalito, CA 94965
 p. 35 — *Point Bonita Lighthouse*
 © Jerry Stitt
 collection of Mr. Roswell Schenck,
 Albuquerque, NM
 p. 81 — *Ballard* © Jerry Stitt
 collection of the artist
KiKi Styke, 7415 Bridge Way, West Bloomfield, MI 48322
 p. 57 — *Cat in a Hat* © Kiki Styke
 collection of the artist
Warren Taylor, AWS, P.O. Box 50051, Midland, TX 79710-0051
 p. 50 — *Big Bend Shadows*
 © Warren Taylor
 collection of the artist
 p. 51 — *Boquillas Agave*
 © Warren Taylor
 collection of the artist
Gwen Tomkow, PO Box 2263,
 Farmington Hills, MI 48333,
 p. 8 & 9 — *Traverse Sunset* © Gwen Tomkow
 Courtesy of Joppich's Bay Street Gallery

 p. 42 — *Cornfield Cosmos* © Gwen Tomkow
 collection of the artist
 p. 77 — *Crazy Socks* © Gwen Tomkow
 collection of the artist
Christine M. Unwin, 6850 Brookshire Drive
 West Bloomfield, MI 48322
 p. 2 — *Gladiolus* © Christine M. Unwin
 collection of Mr. & Mrs. Angelo Vitali
 p. 10 & 11 — *Iris* © Christine M. Unwin
 collection of the artist
 p. 23 — *Poppies* © Christine M. Unwin, collection of the artist
 p. 43 — *Balloon Fiesta* © Christine M. Unwin
 collection of the artist
 p. 44 — *Bandelier National Park* © Christine M. Unwin
 collection of Dr. Thomas & Mrs. Kimberley Prater
 Springfield, MO
 p. 86 — *Cappuccino* © Christine M. Unwin
 collection of the artist
 p. 90 — *Balloon Fiesta* II © Christine M. Unwin
 collection of the artist
 p. 91 — *Corfu* © Christine M. Unwin, collection of the artist
 p. 93 — *Roman Wall* © Christine M. Unwin
 collection of the artist
 p. 96 — *Marigot, St. Martin* © Christine M. Unwin
 collection of the artist
 p. 98 — *Nino is Here* © Christine M. Unwin
 collection of the artist
 p. 124 — *Metamorphosis* © Christine M. Unwin
 collection of the artist
Karen Carter Van Gamper
 5085 Buckingham Place, Troy, MI 48098
 p. 17 — *Hidden Heart* © Karen Carter Van Gamper,
 collection of the artist
 p. 26 — *Stairways* © Karen Carter Van Gamper
 collection of the artist
Susan Vitali, 3 Aircraft Court, Midland, MI 48642
 p. 22 — *Orchid Series # 2* © Susan Vitali
 collection of the artist
 p. 67 — *House Series # 4* © Susan Vitali
 collection of William and Paula Sarge
Donna Vogelheim, 36419 Saxony Dr., Farmington, MI 48335
 p. 71 — *Kimberly's Nest* © Donna Vogelheim
 collection of the artist
 p. 74 — *Tea & Fruit with Old Bags* © Donna Vogelheim
 collection of the artist
Frank Webb, AWS, 108 Washington St., Pittsburg, PA 15218
 p. 28 — *Abandoned Quarry* © Frank Webb
 collection of the artist
 p. 39 — *Port Clyde* © Frank Webb, collection of the artist
 p. 64 — *Wilson Mill* © Frank Webb, collection of the artist
Frederick Wong, 77 Chambers, New York, NY 10007
 p. 117 — *Kim Meredith* © Frederick Wong
 collection of Mrs. Frederick Wong
Lynne Yancha, AWS, RFD # 1 Box 223-AA,
 Mt. Pleasant Mills, PA 17853
 p. 102 — *Sweet Breath* © Lynne Yancha
 collection of Tom and Christine Kimble
 p. 103 — *The Gatherer* © Lynne Yancha
 collection of Joseph and Linda Sweeney
Peggy Zehring, 832 31st Ave S, Seattle, WA 98144
 p. 126 — *Learning to Spin* © Peggy Zehring
 collection of the artist
 p. 127 — *Broken Thought* © Peggy Zehring
 collection of the artist

Index